THIS IS WHAT A LIBRARIAN LOOKS LIKE

THIS IS WHAT A LIBRARIAN LOOKS LIKE

A Celebration of Libraries, Communities, and Access to Information

Kyle Cassidy

BLACK DOG
& LEVENTHAL
PUBLISHERS
NEW YORK

Black Dog & Leventhal Publishers
Hachette Book Group
1290 Avenue of the Americas
New York, NY 10104
www.hachettebookgroup.com
www.blackdogandleventhal.com

First edition: May 2017

Black Dog & Leventhal Publishers is an imprint of Hachette Books, a division of Hachette Book Group. The Black Dog & Leventhal Publishers name and logo are trademarks of Hachette Book Group, Inc.

The publisher is not responsible for websites (or their content) that are not owned by the publisher.

The Hachette Speakers Bureau provides a wide range of authors for speaking events. To find out more, go to www.HachetteSpeakersBureau.com or call (866) 376-6591.

Print book interior design by Kris Tobiassen of Matchbook Digital

Photograph on page 128 by George Lottermoser

Library of Congress Control Number: 2016953679

ISBN: 978-0-316-39398-0

Printed in China

1010

10 9 8 7 6 5 4 3 2 1

Contents

Alexandria Is Still Burning

How can I help libraries?

That's a question I never really thought about until recently. But now it's something constantly on my mind, because libraries can use some help, and very often the people in the best position to do so are those of us who haven't thought about them for a long time.

If you travel across America talking about libraries, you will meet some people who love them, some who are indifferent, and others who think they are a waste of resources. The functions that libraries serve are bound up with their communities; indeed, the two are symbiotic. The more love you put in, the more you will get out.

Ptolemy I Soter loved libraries. A lot.

In 323 BCE Alexander the Great, after conquering as much of the world as the Greeks knew existed, heeded the advice of a fortune-teller and marched into Babylon through a swamp instead of the main road, caught typhoid fever and dropped dead at age thirty-two. With the taut strings of power suddenly and unexpectedly cut, his generals, the *Diadochi*, divided up the conquered world among themselves. There was an enormous amount of squabbling, backstabbing, and poisoning, which lasted for fifty years, but in time the three largest portions were sectioned off to Antigonus, Seleucus, and Ptolemy. Within these three kingdoms would exist all the Seven Wonders of the Ancient World, five of which had already been constructed. Antigonus's kingdom contained the Statue of Zeus at Olympia, the Temple of Artemis, and, later, the Colossus of Rhodes. Seleucus inherited the Hanging Gardens of Babylon and the Mausoleum at Halicarnassus. Ptolemy inherited the Great Pyramids of Giza and built the Pharos Lighthouse. (The Colossus of Rhodes was built by the joyful citizens of Rhodes after Ptolemy sent

his navy to prevent Antigonus from sacking it in 305 BCE, making him, obliquely at least, responsible for 29 percent of the Wonders of the Ancient World, which is nice to have on your résumé if you're trying to compete with Alexander the Great.)

Perhaps Ptolemy acquired his love of learning from Alexander, who in turn may have inherited it from his teacher Aristotle, or perhaps developed it on his own. In any event, after helping to conquer pretty much every blade of grass between Thrace and the Himalayas, Ptolemy settled down in the extremely unfashionable delta of the Nile on the Mediterranean Sea and set out to build the greatest library on Earth. I'd like to think that this is what he would've preferred to be doing while conquering the world; his statue in the British Museum suggests the kind of man that people like to be around. He's wearing the pharonic nemes headdress, smiling and looking for all the world like a man who loves books and cats. (His bust in the Louvre looks nothing like this, but I'm a dreamer.)

Egypt was a squandered kingdom by the time Alexander arrived. Its past glory had been eroded by the Persians, who conquered it in 525 BCE and, for most of the next two hundred years, beat the wealth out of it like dust from a rug. When the Macedonian army arrived after conquering Gaza, the Egyptians were so happy to be rid of the Persians that they gleefully, it would seem, handed the crown over to Alexander without a fight. The Egyptian capital of Memphis had been a fine place to rule Egypt from; it was the closest place to the delta that didn't more or less vanish under a foot of silt every year when the Nile flooded. It was, however, uselessly remote for someone who wanted to rule the entire world. Alexander needed a deep-water port on the Mediterranean for a navy. Greek engineers were able to build on marshlands where the Egyptians had failed to do so. Alexandria, as a city, was built from nothing, but Ptolemy dreamed big and wanted it to be the most sophisticated city on Earth. He began amassing books and scholars. Every mathematician, astronomer, philosopher, poet, and thinker in the region flocked to the new

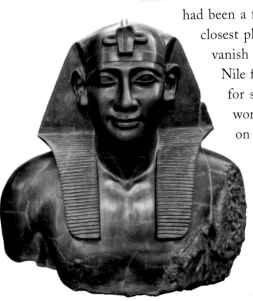

Bust of Ptolemy I Soter, British Museum

capital of Egypt to research, talk, teach, and create. It was a bacchanal of the intellectuals that was to last two centuries.

We don't know a great deal about the Great Library itself; primary sources are scarce. We know that it was built around 300 BCE, with Ptolemy's sumptuous and extravagant goal of amassing all the knowledge on earth, and we know that it burned.

In all likelihood it burned on at least three separate occasions, but even before it burned the Great Library of Alexandria was already a shadow of its former self. It flourished for two hundred years and then died a slow, whimpering death of neglect over the next seven centuries.

The Ptolemaic dynasty had already been in decline for ten decades when Julius Caesar accidentally set fire the city while trying to burn the Egyptian fleet to the waterline in 48 BCE, long before Pope Theophilus set it ablaze in 391 CE, and Caliph Omar sacked the capital in 639 CE. After the most auspicious and noble beginnings the rulers of Alexandria had become distracted, focusing their attention, and their money, elsewhere. Death came not in one fell swoop, or in three major fires, but in a thousand little cuts. One by one new rulers abandoned the principles and practices that Ptolemy knew were critical to knowledge, discovery, and progress. Budgets were slashed, salaries of scholars were cut, and eventually all foreigners studying there were expelled. The later Ptolemys (there were many; Cleopatra VII was the last) diverted their attention to wars, religion, inbreeding, and the occasional matricide. And then, when Egypt was at its most preoccupied with petty squabbles, the Romans took over and for seven hundred years used the country as a larder, shipping grain back to Rome to feed the Empire.

As you trace what little remains of Egypt's history, over the years references to the library grow fewer and farther between. Paulus Orosius, a fourth-century Catholic priest, in his *History of the Pagans* written around 400 CE talks about boxes of books in "temples" but mentions no Great Library. What the fires burned were remnants of a memory. Had the library buildings been repurposed? Were their treasures lost, discarded, stuffed into attics and cellars? Who knows. If a librarian wrote a lamentation about the decline of the Great Library, it hasn't survived.

What made the library of Alexandria great wasn't just the collection of books, but rather its intellectual raison d'être: the insatiable pursuit, creation, and dissemination of knowledge as a force to drive civilization. This whirlwind drew the greatest minds on earth into one place where they studied, taught others, and improved the world based on what they learned there. The scholar Euclid came to Alexandria,

where he wrote a treatise on geometry that we are able to still use today only because it existed in translation elsewhere. Eratosthenes of Cyrene, the chief librarian, not only knew that the earth was round more than a millennium before Columbus waved his feathered hat to Queen Isabella and sailed out into the sunset, but calculated its circumference and the tilt of its axis with astounding accuracy. The historian Manetho was the first to assemble the names and reigns of all the Egyptian dynasties; he wrote *Aegyptiaca*, a history of Egypt that began before the First Dynasty of Menes and went right up until Alexander's arrival. Tragically, nothing of this remains. The great poet Callimachus cataloged all the library's scrolls; of his own purported eight hundred books only six poems and some marginalia survive.

All this learning, compiled over hundreds of years, was left to bleed away.

Libraries in America today are at a crossroads, facing dangers not unlike those of the Great Library, as well as an evolving technology that has the power either to make libraries exponentially more valuable or to erode their foundation if we are not careful.

In January 2014 a librarian named Naomi Gonzales invited me to come to the American Library Association's midwinter meeting in Philadelphia. She promised me that librarians were both friendly and photogenic.

At that point in my life I hadn't been inside a library in more than a decade. The world had changed and an Amazon Prime account and a fast Internet connection had taken the place of my walking five blocks to check things out. That wasn't always the case, though. My mother was a librarian in my hometown when I was growing up, and I spent a lot of time there. My library card number was 205. That's how early we got into the system.

Our small library was housed in the historic mansion of one of the town's founders. When my mother worked nights my father and sister and I would spend the evening at the library waiting for her to finish. It was a comfortable building, filled with tall shelves, wooden floors, stained-glass windows, and a delightful shelf of discarded books that could be bought for ten cents (paperback) and twenty-five cents (hardback).

Later the library moved across the street to an old supermarket with much more room. The services expanded to include reading groups and comfy chairs. At that point, libraries hadn't changed much for the previous fifty years. The library my mother worked in was essentially the same library she visited as a child: a room filled with books.

In 1909 E. M. Forster wrote "The Machine Stops," a twelve-thousand-word short story about a future where people live alone, underground, their needs tended to by an intricate machine whose reach spans the entire globe. Any interaction with other humans is done via videoconference.

Forster's prescient story foreshadows many of the significant changes that have taken place in the world while I've been alive. Before the easy availability of VHS and Betamax machines in the late 1970s, movie delivery was at the whim of television stations and movie theaters. Viewers had to wait for a station to decide to air a movie, or a studio to re-release a film. The videotape industry uncorked the djinn of desire immediately fulfilled. "I want to watch *Gone with the Wind* and I want to watch it *now*."

Digital transmission of data came rapidly on the heels of VHS: computers, modems, and finally the Internet turned the world inside out. Forster's machine had come to life. Almost anything could be transmitted by pull rather than push technology. At the same time, online stores like Amazon, AbeBooks, and eBay gave us new and used books delivered, for a quarter of the retail price. Who needs a library when the machine will send books to your door? People could sit in their homes and let the world come to them.

Well, some people.

As many of us have drawn away from libraries and retreated into a digital world, there are those who simply can't afford their own access to computers, Internet connections, DVDs, video games, and the digital and audiobooks that are downloaded to tablets and phones. Libraries have stretched themselves to begin providing these services for people who can't leap across the digital divide—which quickly becomes a social divide that bars individuals from having the same opportunities as others.

When the recession hit the country, lawmakers, fresh from having all their books, movies, and news delivered via the Internet, began to look for ways to save money in cash-strapped cities. Libraries were often the first victims of budget cuts.

In 2009, in my own city of Philadelphia, Mayor Michael Nutter announced his "doomsday budget," which caused the Philadelphia Free Library System to announce that it was going to close every single branch. Director Siobhan Reardon posted a memo at each library, listing the services that would no longer be available when the doors closed: programs for children and teens, after-school programs, computer classes, programs to support small businesses and job seekers, visits from day care,

community, and senior centers, community meetings, GED, ABE, and English as a Second Language programs as well as *borrowing books*. Turns out that the one thing people thought libraries did, loaning books, was just a part of a vast array of services being provided for the two million people in the Greater Philadelphia area. People in the city *freaked out*, in the grabbing-their-hair-and-spinning-around-in-circles sort of way. People who hadn't been to a library in twenty years as well as well-known writers such as novelist Cory Doctorow bombarded representatives with pleas to save the libraries. With less than two weeks to go before the libraries were to begin shutting down, the state senate voted 32–17 to provide funding.

Local crisis narrowly averted. Nationwide, however, libraries are facing difficult choices and shrinking budgets while at the same time trying to expand their services.

At the American Library Association's 2014 midwinter meeting I photographed and interviewed thirty librarians about the challenges facing their profession. My eyes were opened to many library functions people might not be aware of, like providing Internet access and even shelter to communities that lack it. I learned about research librarians and collections librarians and the myriad people who don't stand behind the counter. I met a librarian from Alaska whose library provided the only Internet connection in the entire town, a librarian whose job it was to improve access to HIV/AIDS-related health information for patients, the affected community, and their caregivers, and youth services librarians who fought battles to keep LGBT books on shelves.

In short, I met thirty people fighting, with both fists and a fierce cry, in myriad different ways, for the public's access to knowledge.

How can I help libraries? I could help share these stories. When it was all over, I sent a photo essay to *Slate* magazine, and they ran it in March. It went viral in the first few hours, which was like being strapped to the front of a rocket. People around the country started sharing memories of libraries from their lives then and from their past. It went on for a week, at the end of which I realized that this project was bigger than a slide show on a popular Web magazine. I went to the crowdfunding site Kickstarter and raised money to attend the American Library Association's annual meeting in Las Vegas with the goal of photographing one hundred more librarians. I spent four days there, and had six incredibly well-attended photo sessions during which I was able to photograph and interview 307 librarians and get a much more robust picture of what they were doing. I went back again, to Chicago in 2015 and Orlando in 2016, meeting more and more librarians

and hearing more and more stories each time. The photographs are merely a trick; their purpose is to get you to look, and then listen.

What are your memories of libraries? In school, for me, the library was both a refuge and a retreat. I think there's little that can supplant a librarian who knows what you like to read. I devoured 1950s-era science fiction like Lester del Rey's *Rocket Jockey*, and also fantasy and historical fiction, driven by librarians who knew what to show me next, because they read and loved and cared. There are books I remember reading and loving whose names I can't recall, but I can still tell you where they were shelved. The library was a safe place filled with thousands of potential life-changing friends who couldn't talk to you, but would tell you a story nonetheless. It is the place that has become the genesis of many conversations, the field from which grew shared experiences with people I've yet to meet. *Have you read . . . Have you read . . . Have you read . . . ?*

When I started college I couldn't afford textbooks and the library was a necessity, but after that we drifted apart. While I was away libraries around me were changing. The Internet was happening, with its heavy requirements for participation: expensive equipment, a phone line, and the promise that if you had to uproot, you'd also have to bring all this stuff with you. For a while Internet cafés filled some of the void for people who didn't have computers. You could pay for an outrageously priced cup of coffee and email all afternoon. Soon enough, though, Internet cafés died out, dividing the world into those who had reliable access to the Internet and those who didn't.

Libraries in the literal sense of the word are not rare things. F. Scott Fitzgerald's infamous antihero Jay Gatsby had a library, lined floor-to-ceiling with books whose pages are uncut, a status symbol, a crutch for his missing sophistication that is only unmasked if someone tries to read them. Being a bibliophile does not make one a reader of books. Jorge Luis Borges presents us with a library of nonsense where most of the books are gibberish. Collecting books is not necessarily helpful. What changes a collection of books into something useful is a librarian: a curator, an indexer, a manager, a gardener who knows what to cut back, what to add, what to highlight, and, most of all, what the community around them needs to grow as a society.

Around us libraries are turning into providers of services of all kinds to communities where there is often no other mechanism for deploying such services. Not just Internet access, but shelter—warmth in the winter, air-conditioning in the

summer—de facto child care for weary parents, and in some cases even food. From the first days of Alexandria, the mission of libraries hasn't been simply books. They are a safety net for civilization.

Over the years librarians have also consistently stood up against censorship in the fight to keep information free and available. When the Patriot Act forbade librarians from even telling people that the FBI had come in to search their records, some librarians began putting up signs saying THE FBI HAS NOT BEEN HERE TODAY. Part protest and part practicality, this was a defiant act against an obvious attempt to keep tabs on who knew what.

Librarians, I've come to realize, are not unsung heroes. Reading the praises in comments sections and on blogs as people shared the photos from the *Slate* article showed me how loved they are. Still, however much that is, I'm compelled to add my voice to the chorus.

With the exception of the pyramids, all of the Seven Wonders of the Ancient World have been destroyed. Of all of them only two were practical—the lighthouse and the library—and of all of them, practical, artistic, and monolithic, the Great Library is the only one that lives on ideologically. That's because the Great Library wasn't about books, or architecture, it was about *knowledge* and it was about *access to information*. The massive achievement of Ptolemy was the idea that accruing knowledge and distributing it would create more knowledge for the betterment of everyone.

As Sir Isaac Newton famously said in a letter to Robert Hooke,* "If I have seen further, it is by standing on the shoulders of giants." Ptolemy's quest to acquire all the knowledge on earth invoked not just the shoulders of giants, but the shoulders of everyone else, every bad poet and mediocre historian as well as every great astronomer and physician. His idea was that humanity moved forward by climbing the achievements of others, giant or not. The Great Library's powerful and enduring legacy—the idea of using state resources to acquire information for the purpose of developing knowledge as an object of power and that society would be better for it—that was the real wonder.

What we do to preserve it is up to us.

* You can see the actual letter Newton wrote to Hooke in the library of the Historical Society of Philadelphia. Thanks, librarians.

FOBAZI M. ETTARH

Libraries are important because students these days are not actually competent at navigating the digital world. Librarians help them not only navigate the digital sphere, but become better global citizens.

MLIS Student
RUTGERS UNIVERSITY

ADY HUERTAS

Librarians are extremely relevant and do a wonderful job at keeping up with emerging trends and technology. As a teen librarian I feel as though I have the best job in the world and I bring my passion for working with teens to everything that I do.

Manager, Pauline Foster Teen Center
SAN DIEGO PUBLIC LIBRARY

PETER HEPBURN

Libraries have room for all of us, and though we grow and change throughout our lives, they will always be a comfortable fit. The library belongs to us all, and I take a lot of pride in ensuring that library users feel they, in turn, belong there.

Head Librarian
COLLEGE OF THE CANYONS,
SANTA CLARITA, CA

ALEA PEREZ

Impassioned librarians are a force to be reckoned with. We have the curiosity of a scientist, the work ethic of a teacher, the creativity of an artist, and the ferocity of a prize fighter. We are so much more than Google.

Head of Youth Services
WESTMONT PUBLIC LIBRARY

LATANYA N. JENKINS

The greatest challenge we face today is the lack of a comprehensive way to make resources available. Libraries provide access to information, connecting people and the things they're looking for. If my library shut down tomorrow there would be chaos.

Reference Librarian for Government Information & African American Studies

SAMUEL L. PALEY LIBRARY

SARAH PRESKITT

While it's true we have the Internet as a means of gathering information, it can be difficult to navigate for those who lack technology and information literary skills as well as Internet access. Even those who can afford Internet access don't necessarily know how to use it—computers and the Web can be intimdating.

Librarian

TIPPECANOE COUNTY
PUBLIC LIBRARY

MATT KRUEGER

Libraries can be—and in many places are—anything their communities need them to be. The power of libraries is their willingness and ability to assess the interests, desires, and needs of their patrons as they change over time. Libraries are community centers, schools, health clinics, post offices, movie theaters, job placement centers, and infinite other things.

Teen Services Librarian

IRONDEQUOIT PUBLIC
LIBRARY

CATHY LIN

I grew up in libraries where I was encouraged to learn about the United States through books. Librarians wear multiple hats. You want to learn how to code? We can point you to the right source. Interested in being an enterpreneur? We'll be happy to support you. We're pushovers until you tell us our funding is cut or that we're not educators. Then we get creative. And fierce.

Library Assistant

MAYFIELD JUNIOR SCHOOL

KYLE K. COURTNEY

Libraries are more important to our world than people realize. We are the "holders of forever" ensuring access to our cultural heritage, while providing the free access and flow of information to anyone in the world. All you have to do is ask.

Copyright Adviser
HARVARD UNIVERSITY LIBRARY

Neil Gaiman

Based on an interview with the author

The first library I ever went to was near Purbrook in Hampshire, when I was about three or four years old, but the first library I really remember was the East Grinstead Library on the London Road. This was a big, old redbrick building that my parents started taking me to when I was about five, maybe six, and I loved it. It had this fantastic children's section, and I remember learning how to use the catalog. The children's area had its own catalog—a subject catalog, which meant I could look up *ghosts* and find all the novels that were *ghosty*. I could look up science fiction or I could just read through all of the authors in the library in alphabetical order. Or I could just roam the stacks and if a book looked interesting, I'd pull it down and read it. On school holidays, probably from about the age of seven until about thirteen or fourteen, I persuaded my parents to drop me off at the library on their way to work. That was my favorite thing to do on the summer holidays. They would drop me off, and I would make my own way home. Very occasionally my dad would embarrass me by insisting I take sandwiches, which I would have to eat in the parking lot. This meant I would have to leave the library at lunchtime, which just seemed like a horrible idea. I would rather be hungry and reading than not reading and eating sandwiches.

I made friends with the librarians because they had information that I needed. I remember things like trying to figure out with them who the author was of the Alfred Hitchcock and the Three Investigators series. *Were they written by Alfred Hitchcock?* I explained that I wanted to read the rest of the books in the series, but the library only had the one. The librarians, who were clearly masters of the interlibrary loan, were able to get me all of the books. It was like magic.

Whoever was stocking East Grinstead Library in some ways formed my taste in books. At that time there was a tiny science-fiction publisher called Denis Dobson, and Denis Dobson would publish authors like R. A. Lafferty. Someone in the East Grinstead Library made sure they had all the R. A. Lafferty books in stock. If you think Lafferty was obscure in America, he was virtually unknown in England! But the East Grinstead Library had all of his books. There are so many authors that I point to now as being hugely influential to my own writing—authors like

J. P. Martin, who wrote the Uncle books, which have just come back into print; and Margaret Storey, who wrote the Melinda books, which have never come back into print, the Melinda Farbright series, which were my Harry Potter books—but nobody's ever heard of them because they were only ever printed for libraries and when the libraries were done with them the books were done.

As a writer, libraries have helped me enormously. The first book I ever wrote was a book called *Ghastly Beyond Belief*, which was a collection of quotations from obscure, weird science-fiction and fantasy books. Some of them bad, but most of them just strange. Without libraries providing the resources and research to find and select these obscure quotations, the book would never have happened. The first book I ever published was a biography of Duran Duran, and it was made possible because there was a newspaper library in London. It was where every newspaper in London was stored. I could go in and read their microfiche; they would print out articles for me. I also owe a huge debt to the British Library. At that time, you had to be a legitimate researcher to get a British Library card. I have no idea how I managed this as a twenty-one- or twenty-two-year-old would-be journalist, but I talked them into it. That little library card, with my photo on it, made me feel more important than I've ever felt, before or since. I would go in sometimes and actually do good things for people, because I had a British Library card.

When we first moved to America I had young children. I would take them to the library and let them walk around, look at books, pick them up, put them down, decide what they were taking home with them for the week. Visiting the library with young children is one of life's great joys, because nothing compares to the experience of picking a book up, holding it, looking at it, seeing the colors, smelling it, and, if you're really small, chewing the edge of it. One of the glories of books is how many of your senses you use to experience them, including smell and the delight of discovering books by serendipity. You simply don't have that with ebooks. I have hundreds of titles on my Kindle, but I am very unlikely to go browsing on my Kindle for something to read. That's the magic of libraries, that possibility of discovering something you didn't even know you were looking for.

The other magic of libraries has to do with curation and categorization. The entirety of human history is characterized by the hunt for information, as if we're searching for a flower in the desert. In today's world of information overload and 24/7 news, we are still looking for that flower, but now we're looking for the flower in a jungle. The jungle may be writhing with poisonous snakes, or something that looks like the

flower you're looking for may not be a flower at all, but actually something quite dangerous or fake. It's a whole weird world. I, for one, am grateful for librarians who can lead out ahead of us into the jungle in our search for our flowers of information.

There was a thing in England recently where they said, *Libraries are on the way out, only a third of UK citizens used libraries last year*. Okay, so that means that more people used libraries than voted for the government that is trying to get rid of them. I think a few things are happening. One has to do with social vulnerability. These days, I only use libraries for incredibly small, specialized, and weird things. That's because I'm an affluent author who has the space and the access to own thousands upon thousands, upon thousands of books as well as immediate access to the Internet. But imagine how library cuts would have impacted and changed the life of seven-year-old Neil Gaiman. I would not be me if those libraries had not existed. People say, *It's all out there on the Web*, but tell me what use this is to people who cannot afford smartphones, and home Internet, and home computers. Most of these folks are connecting to the world through services provided by their library. If you're applying for jobs, looking for information online, the library is the place that provides access. The library's the place where the librarians will explain to somebody how to fill out an online job application.

There are lots of things the government can do to save money. Cutting funding to libraries and education can save a lot of money, and most of us probably won't feel the immediate effects of this loss. But we will. I don't know what the numbers are in the United States, but in the UK the financially underprivileged, illiterate male child is the most vulnerable of beings. You may be thinking that a twelve-year-old boy who can't read is not the end of the world, but that boy will grow into a man not literate enough to function or contribute in society. Reading doesn't only give one knowledge and skills; it helps develop empathy, and without empathy one is much more easily manipulated, by demagogues or politicians playing to fears and feeding a lie, which cannot be verified without access to information or the ability to read. Depriving our communities of libraries will deprive our society of its ability to survive.

Neil Gaiman writes short fiction, novels, comic books, graphic novels, audio theater, and films. His notable works include the comic book series The Sandman *and novels* Stardust, American Gods, Coraline, *and* The Graveyard Book. *He has won numerous awards, including the Hugo, Nebula, and Bram Stoker Awards, as well as the Newbery and Carnegie Medals. He is the first author to win both the Newbery and the Carnegie for the same work,* The Graveyard Book *(2008). In 2013* The Ocean at the End of the Lane *was voted Book of the Year in the British National Book Awards.*

CYNTHIA BARAN

I'm helping create the world I want to live in. It's not fair to expect others to do it for me.

High School Librarian

ENVIRONMENTAL CHARTER HIGH SCHOOL

AMY CHENEY

Librarians are everywhere; in juvenile halls, group homes, homeless shelters, and migrant camps.

Librarian

ALAMEDA COUNTY LIBRARY

ANNIE SILVA

Libraries and librarians exist to enrich and help the communities we live in. We have no ulterior motives, which is awesome!

Senior Support Analyst

ONLINE COMPUTER LIBRARY CENTER

PHIL CUNNINGHAM

Everybody knows what a library is, but only a small percentage know what a librarian does. What do we do? Everything! We are here for you.

Library School Student

PRATT INSTITUTE

LESLIE L. MORGAN

There is a misperception that libraries have been replaced by technology. Libraries provide a way to connect users to knowledge that will have an impact. They innovate and create knowledge tools. I was driven to be part of this process by my love and passion to serve and out of a fear that if librarians go away illiteracy will win.

Head, Teaching & Instructional Services
HESBURGH LIBRARIES
UNIVERSITY OF NOTRE DAME

KATHLEEN DeLAURENTI

Music librarians are fighting for your access to music—iTunes, Amazon, and Google create licenses that circumvent copyright and don't allow libraries to purchase music for patrons to use. There are releases from the Los Angeles Philharmonic to Fugazi that can't be bought by libraries so that we can make sure they're available five, ten, or twenty years from now. Spotify is great, but we're fighting to ensure our patrons never see a grayed out track.

Music Arts Librarian
COLLEGE OF WILLLIAM AND MARY

BETH GALLEGO

A new mom at Baby Storytime remembered me as the "helpful Librarian" from when she visited my branch as a child. The Library gives constant access to generations. It is a growing, changing part of a growing, changing community. To the families we serve, it's not just "the Library." It's "our Library."

Children's Librarian
LOS ANGELES PUBLIC LIBRARY

SCOTT WALTER

It's up to *you* to ensure you have a library. If you want your kid to have a school library; if you want your community to have a public library; if you want your university to have a library, we need *you* to tell the story to the people who matter. We need you so that *we* can have a library in the future.

University Librarian
DEPAUL UNIVERSITY

19

JESSIE NACHEM

Libraries are centers of discovery and a safe place to go where one is encouraged and supported in finding information that is empowering and transformative. That process is what inspires me to be a part of librarianship.

Librarian

THE WRIGHT INSTITUTE
OAKLAND PUBLIC LIBRARY

SUSAN K. McCLELLAND

Librarians are warrior princes and princesses wielding book love like swords! We are ever vigilant, curious, intelligent, and kind. Libraries are the banners that we carry proudly into the fray! Forward, ever forward!

Adult & Teen Services Librarian
OAK PARK PUBLIC LIBRARY

America's First Lending Library
The Library Company of Philadelphia

I don't have to travel far from my house to the Library Company of Philadelphia at 1314 Locust Street. In fact, I can walk to it. Founded in 1731 by Benjamin Franklin, it is the country's oldest cultural institution and was the nation's first Library of Congress. In Franklin's time most of the land west of the Schuylkill River was farm or forest; the actual city of Philadelphia was crammed into a few blocks along the Delaware to the east. Today the city has grown west of its colonial beginnings, and up to the sky.

Franklin arrived in this much smaller Philadelphia full of curiosity and intellect but little means. In 1727 the twenty-one-year-old started a group "of mutual improvement" known as the Junto Club. They met every Friday in a bar to discuss politics, geography, philosophy, science, and other topics that interested them. ("Whence comes the Dew that stands on the Outside of a Tankard that has cold Water in it in the Summer Time?" was one of the questions they wrote in their minutes in June 1732.) Much beer and much discussion caused Franklin to realize just how much he didn't know. "Being ignorant," he said, "is not so much a shame as being unwilling to learn." So in 1731 he and forty-nine of his friends pooled their money, donating forty shillings each and promising ten more per year, to start a library.

Franklin's endeavor wasn't the first library in the country; there were colleges and religious institutions that housed large numbers of books. What made Franklin's so revolutionary, however, was that people who were not members could take books out. It was a library not for the few, but for the many. They hired a librarian to tend to their inventory. A catalog published in 1741 lists 375 books and mentions that the library was open on Saturdays between four and eight p.m.

The library continued to acquire books but also diversified, as did the interests of its members; it became a repository for curiosities including old coins, the hand of a mummy, and scientific instruments: a microscope and a telescope. In 1754 adventurer and sea captain Charles Swaine returned from a disastrous mission to the Arctic in which he had been seeking the mythical Northwest Passage. Some of his crew had been killed by indigenous people; others mutinied. Swaine visited the Library Company and gave them everything that survived the mission: some tools and Inuit parkas.

As the nation grew and Philadelphia became more significant, it attracted the leading intellectuals from all the colonies. During both Continental Congresses lending privileges were extended to the delegates. The original library was housed at Surgeons Hall on 5th Street, near Independence Hall, the building to which it soon relocated when it outgrew its original space. It was here, and with equipment owned by the library, that Franklin conducted his first experiments with electricity.

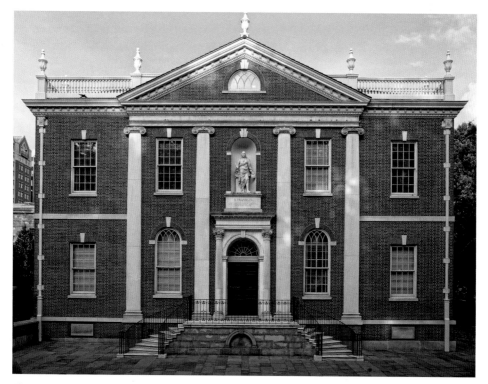

The 1958 reproduction of the original Library Company of Philadelphia, complete with larger-than-life statue of Ben Franklin.

Eventually the library outgrew Independence Hall and moved to its own building next door.

In its later years, after Franklin's fame was celebrated and his fortune cemented, the library erected a larger-than-life statue of its founder dressed as a classical god: wearing a toga, leaning on a stack of books, and wielding a scepter. Though Franklin was alive when the statue was started, and no doubt enjoyed the tribute immensely, he didn't live long enough to see it installed or the new building open. The statue still exists, somewhat the worse for wear, missing both hands and damaged by students from the nearby Episcopal Academy who used it for target practice with their slingshots from a fourth-floor balcony conveniently located within range.

The library moved again in 1800 to its current location on 13th Street, and the original building was razed to make way for an office building built by Anthony Drexel. However, in the late 1950s, experiencing a high sense of nationalistic regret, or perhaps concern over the not-too-distant bicentennial, imagining the slow *tut-tut-tut* of countless tourists chastising the city fathers, the Drexel building was itself razed to make way for a facsimile of the original library. (The building housed, and still does, the Philosophical Society.)

Franklin was proud of his library and well aware of its impact and the impact of lending libraries in general. "These libraries have improved the general Conversation of Americans, made the common Tradesmen and Farmers as intelligent as most Gentlemen from other Countries and perhaps have contributed in some Degree to the Stand so generally made throughout the colonies in Defense of their Privileges," he wrote in his autobiography.

Franklin and his cohort of intellectuals with moderate means produced a lasting and extensive change in the way America worked, helping to wrest power from the wealthy and put it into the hands of the intellectually curious by providing access to information. From these beginnings it's easy to make a journey across the country a journey of looking at libraries and how their quiet innovation has changed, and is still changing, our world.

DOROTHY TERRY

Libraries need to break away from stereotypes so that our communities understand that we have their best interest as our focal point. Librarians provide service beyond self; it's always "What can I do for *you*?" I have great passion for this. I love it when a student walks away with new knowledge—there is no better feeling.

Social Work Librarian

UNIVERSITY OF MARYLAND, BALTIMORE

LEIGH MILLIGAN

Libraries are important because they can make a difference in one's life. They are superinformation centers that are essential to providing accessible information to all.

Lead Librarian

MEDRISK, INC.

ANNIE PHO

If you care about lifelong learning, democracy, and equality, then you need to care about libraries. That's why I became a librarian; because I want to help people succeed in life.

Inquiry and Instruction Librarian
UNIVERSITY OF ILLINOIS
AT CHICAGO

AMY CALL

Libraries strive to be a safe place for the maligned members of our communities. Librarians want you to be welcomed and find a second home with us.

Reference and Instruction Librarian
MARYGROVE COLLEGE

MEL GOOCH

Libraries encourage creativity and innovation and provide opportunities
for lifelong learning. Librarians are the ultimate search ninjas.

Librarian III, Main Library 5th Floor Manager

SAN FRANCISCO PUBLIC LIBRARY

GRETCHEN CASEROTTI

I was always a library kid. What drew me to my calling was the realization that stories can be consumed and created in many ways, and that technology is a powerful tool to do that.

Library Director

MERIDIAN LIBRARY DISTRICT

MICHELLE MOORE

Libraries and librarians will never go away. It doesn't matter how things change or develop. We will always be needed to advise, answer questions, and guide others to lifelong learning.

Library Director

ARDIS MISSAUKEE DISTRICT LIBRARY

NATASHA ARCE

I believe in the library as a place for a great exchange of information, discovery, and creativity. The ability to access years of knowledge provides an opportunity for self-improvement and the ability to make change. Libraries encourage open minds with open doors, open books, and open screens.

International School Librarian

SCHOOL OF THE NATIONS MACAU

NAOMI GONZALES

To me, libraries will always be a place of discovery and empowerment. We help equip people
with the knowledge they need to face their challenges, no matter how personal or epic.

Public Health Coordinator

NATIONAL NETWORK OF LIBRARIES OF MEDICINE

DOUG CAMPBELL

I became a librarian because I love to help people
and that is what librarians do best!

Research & Instruction Librarian

UNIVERSITY OF NORTH TEXAS

PAULA MAEZ

Knowledge is power. I want to help others feel
empowered. Everyone deserves the opportunity.

Librarian / PhD student

PIMA COUNTY PUBLIC LIBRARY /
UNIVERSITY OF ARIZONA

SAMANTHA MARISON

Libraries are the heart of community learning.

Student/Aspiring Librarian

UNIVERSITY OF CONNECTICUT

NNEKAY FITZCLARKE

Librarians are the gateway to information. We want to inform those who surround us.

Reference Librarian

DOMINICAN UNIVERSITY OF CALIFORNIA

Amy Dickinson

I've made my share of mistakes as a mother, to be sure.

There was the time I sent my daughter Emily to school with an empty lunch box.

I never made her play soccer or stick with ballet, and I missed her one big rebound in basketball because I was reading a magazine on the sidelines. By the time I looked up, it was too late.

Sometimes I took my kid to R-rated movies because I was a lonely single mother and couldn't always get a sitter on a Friday night.

But I did one thing right: Emily and I spent a lot of time at the library, walking down Connecticut Avenue from our apartment in Washington to visit the crumbling library on the corner.

In the summers, spent in our little house on Main Street in my hometown in upstate New York, we visited the Southworth Library, where my grandmother and mother took me as a child, and where I learned to read when I was seven. While my mother was combing through the stacks, I leafed through *Green Eggs and Ham* for the four thousandth time, and finally the words stopped swimming beneath the pictures and I realized that each word corresponded with something specific. I quickly graduated to a series of biographies written for children, and worked my way through the entire shelf. My mother, Jane, always let me bring home as many books as I wanted, and what I learned is that if you have a book, you are never alone.

We lived on a tumbledown dairy farm at the edge of the village, miles away from any bookstore, and with no money to buy books. My mother visited the Southworth Library every week. She had highbrow taste and always carried a book. When I was in high school and a cheerleader for the basketball team, she was the only spectator at events who read Tolstoy during the game and looked up from her book during the floor routines.

One time, seeing off a family member at the Greyhound bus station, my mother wrote "Goodbye, we'll miss you" on the flyleaf of a library copy of *To the Lighthouse* and held it up to the bus's window, because she didn't have a piece of paper. I was eight years old and excessively worried about the defacement. But she knew she would be forgiven.

We did, however, suffer under the threat of late fees. My mother taught me to carefully guard my library books and adhere to the due dates stamped on the cardboard sleeve glued to the books' inside cover. We could not afford to get behind.

My daughter grew up with Harry Potter. She had a habit of reading in bed in the mornings, and would start to re-read a book the minute she had finished it. When she was a teenager, she graduated from Potter to Trollope, plowing through the Chronicles of Barsetshire, lying in her creaky little spool bed in her small summer bedroom. When she was an older teen and able to drive, she would take herself to the large library in Ithaca and occasionally spend the day there. At nineteen, she changed her Facebook status to say she was "in a relationship" . . . with the library.

Ten years ago, I wrote my own book. I proudly snapped a picture of the spine of my memoir, shelved in the stacks at the Southworth Library—the very place where literacy had first found me. Our little library continues to serve the small rural community, hosting book club meetings and story time on Friday mornings, which are crowded with tiny pre-readers who clutch one of the library's collection of stuffed animals as they listen to a story.

When people like me talk about libraries, we wax on nostalgically about the stacks. The feel of a book. The little dusty-paper smell that escapes when you first crack a volume open—and how we associate that with the unleashing of an idea. When I took out my very first book from the library, my name was entered on a library card removed from a sleeve inside the back cover. The librarian stamped it with a magnificent and fascinating date stamp, affixed cleverly to the end of her pencil. When I took out a book I could see the names of all of the other people who had also read this book. One time, I saw my own mother's name on the card. Talk about time travel: a mother and daughter consuming not just the same story, but the exact same book—turning the very same pages—decades apart. Two summers ago, my daughter took out the very same book (*The Collected Stories of Eudora Welty*), stretching the literary loop between generations.

Our local library has abandoned their card system. There's no more thump from the stamp, no more pencil scribbles on cards. You can no longer look at the card sleeve in the back of the book and see that it was taken out by your neighbor in 1985. But now when a kid takes out a book, the librarian lets the child ring a bell to mark the moment. So I guess that's something.

Because of my ongoing involvement with this library, I met an adolescent in town whom I suggested might want to stop in to satisfy a homework assignment. She sheepishly admitted that she didn't ever visit the library because of a long-

ago late fee that her parents had never paid, left over from when she was a much younger child. Her fear over the fee had prevented her from as much as setting foot inside the institution for several years. I went inside and paid her fee, which (with interest) had grown to over seventy dollars. When I told her the fee was paid and the coast was now clear, she burst into tears. But will she ever feel comfortable in the library? I doubt it.

I get it—of course—that late fees are more or less built in to the library concept. Late fees raise revenue and provide a financial incentive for people to return their materials so the library can keep them in circulation. But late fees don't do any of these things if they are never collected. An uncollected late fee on children's material not only does no good to the library, but can also ruin a parent's credit.

Late fees are the enemy of early literacy because instead of promoting responsible behavior, they suppress library visits for some of the people who need the institution the most. And of course these fees don't promote children being more responsible, but only reveal to children how irresponsible, ignorant, or unaware their own parents are.

Three years ago the New York City public library system announced what they called an amnesty program for young people. They said the children could "work off" their late fees by reading. The "fine" was fifteen minutes of reading for each dollar they owed.

And it involved 143,000 children, because that is how many kids were listed in the system as owing fees.

I don't have any data on how successful the program was, but I assume that there are probably about a hundred thousand children in New York City who will never set foot in a library again.

Families should not be assessed late fees for children's books—instead the library should adopt the technique successfully used by Netflix for DVD rental: When children turn books in, they can take new books back out.

My own book has sold well. It hit the *New York Times* bestseller list and continues to have a waiting list of eager readers at the Southworth Library. So last Christmas Eve I stopped by the library and as a Christmas gift used some of the proceeds of my own book to pay the late fees for all the kids in our town who were in arrears. This involved over a hundred children who owed fees ranging from under a dollar up to almost one hundred dollars. Each family received a letter from the library saying their child's fees had been waived—and urging them to come back inside.

This was an effort to save not the institution, but the people who might use it. Children need books, and they need people in their lives to nurture their love

of story. They need to understand that stories get made up and written down, and that the library is full of ideas and incident and glancing magical connections that happen across space and through time: like the one among my mother, my daughter, and me.

Amy Dickinson is the author of the New York Times *bestselling memoir* The Mighty Queens of Freeville: A Story of Surprising Second Chances. *She writes the syndicated advice column* Ask Amy, *which is carried in over 150 newspapers and read by an estimated twenty-two million readers daily.*

TAINA EVANS

Librarians empower users in their pursuit of knowledge, learning, and in discovery and research across all disciplinary fields, transcending race, color, and creed. By far the most valuable institution available to the public, for free. I love working here, empowering others.

Library Information Supervisor
BROOKLYN PUBLIC LIBRARY

KATE KEITH-FITZGERALD

A library is a safe space where everyone can come to learn, create, and connect with their community. As a librarian, I connect with kids on another level. They see me as an ally. I understand Fandor and Minecraft, so they share with me in a way they wouldn't with someone else. That's a huge responsibility for me and I need to work to make the library safe for them to find out who they are.

Librarian and teacher
LEWES PUBLIC LIBRARY

KATHY ROSA

When I was in middle school I volunteered to work in the school library. While shelving books I realized that all the world's knowledge could be accessed through libraries. My epiphany lead me to my career as a librarian so I could help other people.

Director—Office for Research and Statistics
AMERICAN LIBRARY ASSOCIATION

MANDY McGEE

If anything, I think the existence of the Internet actually increases our relevancy. I mean where else in your community can you go to get free unlimited personal assistance navigating the vast online universe?

Adult Services Supervisor
ELMWOOD PARK PUBLIC LIBRARY

JENNY LEVINE

Libraries are the last safe, noncommercialized space that truly welcomes everyone in the community and brings them together. They're the great equalizer.

Executive Director

LIBRARY AND INFORMATION
TECHNOLOGY ASSOCIATION

ALEX GATES

When I was sixteen, I started working at the downtown Tulsa City County Library. There I met amazing diverse people who helped form my early world view. Libraries are safe places, places to explore both who you are and what the world has to offer. Safe for ideas to come out and spread their wings. Safe for kids to read about the issues they face, and the good and bad sides of the world.

Future Librarian

LANE GOLDSZER

Libraries are a free space.

Page

JP PORCARO

The best quote I found about libraries is actually by Keith Richards of the Rolling Stones. He says, "When you're growing up there are two institutional places that effect you most powerfully: the church which belongs to God and the public library which belongs to you."

New Jersey Chapter Councillor

AMERICAN LIBRARY ASSOCIATION COUNCIL

BRIAN FLOTA

The problems facing libraries today are the same ones as always: money and space. Funding, especially at public libraries, is at a premium. With more books being printed than ever before, there simply isn't enough space. With more digital content, storage capacities are continually being pushed to their limits. Libraries provide a physical space for metaphysical journeys. They also provide the stuff of real life: learning to read, finding employment, developing interests, finding friends, creating connections to a world beyond one's self.

English Librarian
JAMES MADISON UNIVERSITY

LINDSAY DAVIS

I am a first generation Latina college student now working as a community college librarian in California's Central Valley, where I grew up. I did my undergrad work locally at CSU Stanislaus. I took a library resources class and couldn't believe how useful it was. Without librarians and instructors teaching students how to do research, many students never learn that there is a better way to do and learn things. I remember what it was like to learn the ropes, and I love that I've come full circle and am making a difference by encouraging and teaching students in my region.

Instruction Librarian
UNIVERSITY OF CALIFORNIA, MERCED

ALIQAE GERACI

I am a labor relations librarian at a university. Any given day, I might be teaching a class on labor law research to undergraduates, directing a job seeker to salary data, helping a rank and file union member locate a contract, or providing historical employment statistics to a faculty member. Work, or lack of work, is core to human experience and identity, and Catherwood Library plays a crucial role in organizing, preserving, and providing access to current and historical information on labor relations and workplace issues, human resources, and labor economics. There are so many different kinds of libraries and librarians! What unites us all is our role as sense-makers of complicated information environments. We renew our relevance every day through our work, by maintaining the trust of our patrons, and by advocating for libraries and library workers in our communities and institutions.

ILR Research Librarian
CATHERWOOD LIBRARY, CORNELL UNIVERSITY

 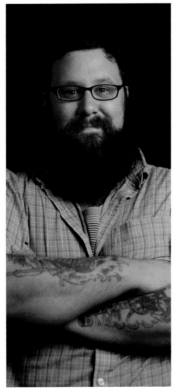

HEATHER MORRISON

Wyoming has a way of isolating people; libraries have a way of connecting them.

Library Media
RIVERTON HIGH SCHOOL

TURNER MASLAND

Libraries are still relevant. They might not look the same, and they will continue to change, but they still offer vital community services.

Access Services Assistant Manager
PORTLAND STATE UNIVERSITY

LAURA BRAUNSTEIN

Libraries ensure our access to information, and information empowers people toward freedom and liberty.

Digital Humanities and English Librarian
DARTMOUTH COLLEGE

A Library of Mud

*Steve Tinney and the Tablet Room
at the University of Pennsylvania*

Not only did Benjamin Franklin start America's first lending library (see "The Library Company of Philadelphia"), but he also launched one of its great institutes of learning. At the time of its founding the University of Pennsylvania was just a few hundred yards from Franklin's library, on 4th and Arch Streets, but like the Library Company of Philadelphia the university has moved several times over the years and now resides on 299 acres of land two miles away. It also now houses one of the most unusual libraries in the world.

Dr. Steve Tinney isn't exactly a librarian, he's a Sumerologist, but the books in his library are so specialized that almost no one on earth can read them. This makes people holding the qualifications for his position extremely rare; a master's in library science alone won't do. Hidden away on the second floor of the University of Pennsylvania's Museum of Archaeology and Anthropology is the Tablet Room, a fluorescent-lit warren stuffed with drawers and shelves. Housed in these spaces is a unique collection of clay tablets that is proving key in the decoding of the Sumerian language, a language whose last native speaker died around four thousand years ago. At the time Franklin was hoisting his first beer with friends in the Junto Club every single one of these tablets was buried in the sand under modern-day Iraq, where some of them had lain undisturbed for six thousand years. In 1888 archaeologists from Penn began unearthing them.

As civilization flourished, population increased. With the first great city, Sumer, came the first great bureaucracy; trading in massive amounts of grain and livestock and metals became too complex for handshakes. Humans need a history, and a

history that is entertaining is sometimes more valuable in the long run than one that is accurate. When trade becomes the business of a city, though, history needs to be precise. For that you need receipts, and for that you need writing.

The Sumerians, beginning in 3500 BCE, invented a way to preserve their thoughts. They then proceeded to write down everything: court cases, land deeds, livestock transactions. Along the way, they started writing down stories such as the Epic of Gilgamesh, which tells the tale of the despotic king of Uruk (Gilgamesh) who is so badly behaved that the gods create a wildman, Enkidu, to defeat him. Gilgamesh, while badly behaved, is also charming, so he and Enkidu become great friends and have many adventures fighting demons, giant snakes, and (eventually) angry gods.

Gilgamesh, as we know it today, comprises twelve tablets. One of these is housed in Penn's Tablet Room, where scholars can come and study it. But it is often the other, more mundane tablets that draw scholars, studying things like

Dr. Steve Tinney arranges tablets containing some of the first words ever written.

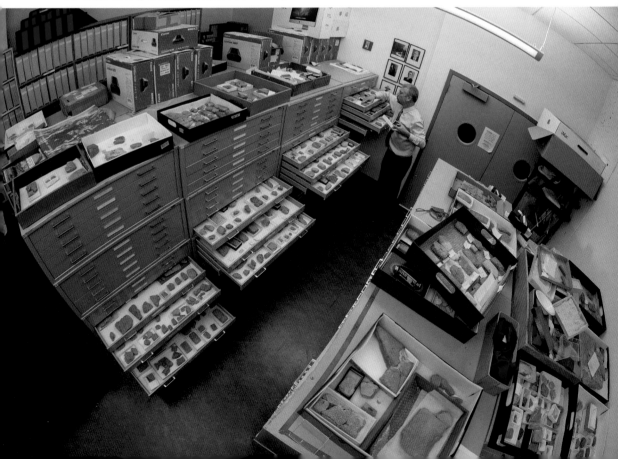

ancient legal codes, economics, or women's rights in the ancient world. Some of the more hard-core philologists might want to look at texts simply because they contain one particular word that's not well understood. A prosopographer studying the physical writing might be trying to track a specific scribe by his or her hand-writing, which can help match the province of a tablet whose origins might not be well known. Likewise, onomastics—the study of names—helps a scholar know that people in lists are from different regions.

If you're a professor on a budget, traveling to Philadelphia to do your research often isn't possible. This is why scholars studying ancient writing systems to reconstruct the societies they belonged to are increasingly turning to digital dictionaries in an effort to accelerate their work. The Penn Museum has been working to digitize its collection for more than a decade and, at the same time, creating a dictionary of the written Sumerian language.

"The Flood Tablet" tells the story of a great Babylonian flood.

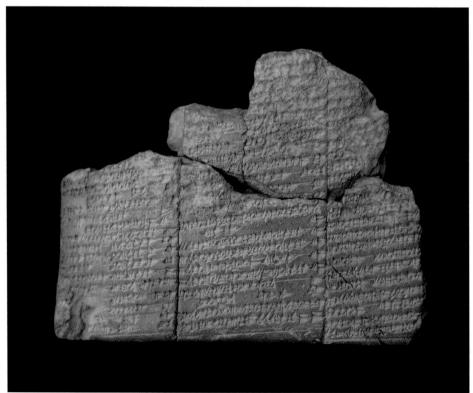

Four thousand years ago, in the Sumerian city of Nippur, scribes were attending classes to learn the relatively new and privileged profession of writing. Practicing their trade on soft clay tablets with a reed stylus, these students prepared for a career in the vast bureaucracy that formed the backbone of Mesopotamian civilization. For the next several millennia, a number of Middle Eastern cultures—the Sumerians, Akkadians, Babylonians, Elamites, Hittites, and Assyrians—would use the wedge-shaped letters known as cuneiform to write correspondence, record their taxes, and remember their myths.

Ancient Nippur, a hundred miles south of modern Baghdad, was a bustling city in its day. In 1889 John Punnett Peters of the University of Pennsylvania began directing an archaeological dig across the site of this once booming city, a mile long and half as wide, which had since been reduced to a pile of detritus sixty feet high. During excavations, Peters and his assistant John Henry Haynes discovered that the entire site was riddled with clay tablets. In twelve seasons, the expedition discovered some thirty thousand of them, which now make up the majority of the Tablet Room's collection.

The Nippur tablets would have remained priceless yet useless slabs had not Sir Henry Rawlinson, an English officer, diplomat, and scholar of ancient languages, discovered three inscriptions etched into a cliff situated ninety yards off the ground in modern southwest Iran in 1835. This veritable Babylonian Rosetta stone was written in three languages: Old Persian, Babylonian, and Elamite. Ascending a wooden ladder, Rawlinson copied the texts and began the task of deciphering them. After translating the Persian version, he deciphered the others, moving from the known to the unknown languages. By the time Haynes arrived at Nippur, Rawlinson had made great strides on Akkadian, a separate and younger Mesopotamian language and distant sister of Arabic. Since it used the same cuneiform writing system as Sumerian, Akkadian was key to deciphering the older language.

Rawlinson's discovery generated a growing interest in the Sumerian language and led to other projects aimed at recovering tablets. Many of the Nippur tablets were brought to the University of Pennsylvania, where scholars studied them. But with thousands of excavated tablets scattered across the world's museums, researchers had difficulty getting a broader view of the vocabulary and grammar. To improve communication among scholars, in 1954 the University of Chicago began publishing the Chicago Assyrian Dictionary, a multivolume work of word

lists. Some twenty years later Professors Erle Leichty and Åke Sjöberg started a similar project for Sumerian at the Penn Museum. Under Leichty and Sjöberg's guidance, scholars carefully examined the thousands of cuneiform tablets in the university's collection, many of which had never been translated before.

The dictionary, which began as a wall-size collection of filing cabinets filled with note cards, was expected to take forty years to complete. In 1984 Leichty and Sjöberg's hard work was rewarded when the University of Pennsylvania Press released a single volume representing the solitary letter *B*. In the years that followed, three more volumes appeared that together covered the letter *A*.

On my visit to the files, I pull open a long green drawer, stuffed with note cards in Åke Sjöberg's own hand, in light purple fountain pen ink, and pick one at random. On it is the word *mucus* and the three times that it's appeared in Sumerian texts.

"How many people know this word?" I ask.

"Including you?" says Leichty. "Three."

Leichty and Sjöberg's research has been handed down to Tinney. Under his direction, the project has moved toward a digital format.[1] Scholars work full-time in the Tablet Room to publish digital photographs of their entire collection on the Internet. Funded by grants from the National Endowment for the Humanities, the Sumerian Dictionary Project is staffed by seven people who have developed several digital techniques for recording high-resolution images of each tablet from multiple angles.

Similar projects, such as the Cuneiform Dictionary Library Initiative, run by the University of California at Los Angeles and the Max Planck Institute for the History of Science in Berlin, hope to provide scholars around the world with unprecedented access to a previously unimaginable library of texts.

The digitization of the library increases the number of people who have access to its contents, but the library itself is just as relevant as ever. "There are things you can get from scans," Director Steve Tinney says, "but these are three-dimensional objects. Sometimes you need to hold something in your hand. Digitization doesn't replace the need for this library; it's one aspect of it."

[1] Thanks to the university's digitization efforts, the word that only I and two other people on earth knew can now be found by anybody who's looking for it. You can find the text of the card online here: http://oracc.museum.upenn.edu/dcclt.

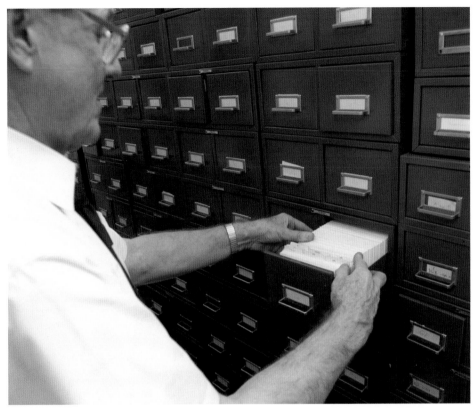

Dr. Erle Leichty peruses Åke Sjöberg's Sumerian dictionary on note cards in 2003.

MARY C. MACDONALD

I work in libraries because they are one of the most democratic and open organizations I know. I sleep well at night. My work is eye-opening, engaging, and fulfilling. Every library user (in my work that is primarily students), provides a new world of information to share, to help them find the answers (and the questions!) that they seek.

Professor and Head of
Instructional Services
UNIVERSITY OF
RHODE ISLAND LIBRARIES

YEMILA ALVAREZ

Lack of engagement by communities in communities is one of the greatest challenges facing libraries today. The library is most effective and providing its services in collaboration with community experts. Without their help and willingness to engage with libraries, communities suffer. Let's work together to better our communities.

Community Engagement Manager
SAN FRANCISCO PUBLIC LIBRARY

LISA NOWLAIN

I came to the library world from the art world. As with art, libraries have the potential to connect people with each other and with ideas. Libraries are a space to imagine the future and acquire the tools to make it happen.

Children's Librarian
DARIEN LIBRARY

DEBORAH MONGEAU

During the Dark Ages, the monks in Ireland copied and preserved much of the knowledge of Europe and are credited with saving Western civilization. Today, with instant information and instant deletion, librarians are now the Irish monks.

Chair of Public Services

UNIVERSITY OF RHODE ISLAND LIBRARIES

MARY ABLER

Libraries are the people's university. As the cost of a formal education rises and the options for learning in non-traditional formats increase, libraries will be the great equalizer, allowing everyone to grow and embrace their passions.

Librarian

SAN FRANCISCO PUBLIC LIBRARY

WICK THOMAS

Public libraries defend free speech, fight for privacy rights, and provide equal access to everyone regardless of income. In an increasingly privatized world where profit often supercedes ethics, the public library stands out as a radical institution. It is the single most important catalyst for an educated democracy and we must advocate for it fiercely.

Teen Services Librarian
KANSAS CITY PUBLIC LIBRARY

TIMOTHY CONLEY

There's something like 2.1 billion indexed Web pages on the Internet and the stewardship of our cultural heritage through digital materials is everyone's responsibility. All this information is freely available at the library.

Technical Services Assistant
CENTER FOR JEWISH HISTORY

JENNISEN LUCAS

The most exciting part of being a school librarian is helping young people become whomever they will become. Schools must prepare students for jobs and careers, and the library is the unique place in the school where students can investigate the possibilities and expand their imaginations. The school librarian is a guide to what's possible, with the skills to teach students how to transform their dreams into reality.

Elementary Librarian
PARK COUNTY SCHOOL DISTRICT #1

DOLLY GOYAL

There's a huge and growing barrier to technology facing a large portion of our population. Millions of people don't have direct access to technology or understand how to use it. Libraries provide free tools and e-literacy services with patience and compassion.

Library Director
LOS GATOS LIBRARY

Cory Doctorow

Every discussion of libraries in the age of austerity always includes at least one blowhard who opines, "What do we need libraries for? We've got the Internet now!"

Facepalm.

The problem is that Mr. Blowhard has confused a library with a book depository. Now, those are useful, too, but a library isn't just (or even necessarily) a place where you go to get books for free. Public libraries have always been places where skilled information professionals assisted the general public with the eternal quest to understand the world. Historically, librarians have sat at the coalface between the entire universe of published material and patrons, choosing books with at least a colorable claim to credibility, carefully cataloging and shelving them, and then assisting patrons in understanding how to synthesize the material contained therein.

Libraries have also served as community hubs, places where the curious, the scholarly, and the intellectually excitable could gather in the company of one another, surrounded by untold information-wealth, presided over by skilled information professionals who could lend technical assistance where needed. My own life has included many protracted stints in libraries—for example, I dropped out of high-school when I was fourteen took myself to Toronto's Metro Reference Library and literally walked into the shelves at random, selected the first volume that aroused my curiosity, read it until it suggested another line of interest, then chased that one up. When I found the newspaper microfilm, I was blown away, and spent a week just pulling out reels at random and reading newspapers from the decades and centuries before, making notes and chasing them up with books. We have a name for this behavior today, of course: browsing the Web. It was clunkier before the Web went digital, but it was every bit as exciting.

(Eventually my parents figured out I wasn't going to school, and after the ensuing confrontations, I ended up at a most excellent independent/alternative school, but that's another story.)

Later, I worked as a page at North York Public Library's central branch, in the Business and Urban Affairs Department. Working at a library is an unparalleled opportunity to witness the full range of human curiosity, from excited students working on school assignments together to wild-eyed entrepreneurs pursuing their

dreams to careful senior citizens researching where to invest their personal savings to supplement their pensions (and lots more besides). All these people were using the library as a place, a resource, and a community. Because that's what libraries are.

And we've never needed that more than we need it today. We've run out of places. What used to be public squares and parks are now malls. Places that used to welcome kids now prohibit them. (In England, where I live, some smart aleck invented a device called the mosquito, which plays a shrill tone only audible to young ears, used to drive children away from semi-public spaces like the benches in front of stores.)

What's more, we're *drowning* in information. Pre-Internet librarianship was like pre-Internet newspaper publishing: "select, then publish." That is, all the unfiltered items are presented to a gatekeeper, who selects the best of them and puts them in front of the rest of the world. Now we live in a "publish, then select" world: Everyone can reach everything, all the time, and the job of experts is to collect and annotate that material, to help others navigate its worth and truthfulness.

That is to say that society has never needed its librarians, and its libraries, more. The major life-skill of the information age is information literacy, and no one's better at that than librarians. It's what they train for. It's what they live for.

But there's another gang of information-literate people out there, a gang who are a natural ally of libraries and librarians: the maker movement. Clustered in cooperative workshops called makerspaces or hack(er)spaces, makers build physical stuff. They make robots, flying drones, 3-D printers (and 3-D printed stuff), jewelry, tools, printing presses, clothes, medieval armor . . . whatever takes their fancy. Making in the twenty-first century has moved out of the individual workshop and gone networked. Today's tinkerers work in vast, distributed communities where information sharing is the norm, where the ethics and practices of the free/open source software movement have gone physical. Such hackspaces play a prominent role in my own fiction (thanks, no doubt, to the neighborly presence of the London Hackspace, which is directly over my own office in Hackney). In my new novel, *Homeland* (the sequel to 2008's *Little Brother*), my protagonist Marcus discovers the tools of personal and social revolution through his friends at Noisebridge, a real-world makerspace in San Francisco.

At first blush, the connection between makers and libraries might be hard to see. But one of the impacts of building your own computing devices (a drone, a 3-D printer, and a robot are just specialized computers in fancy cases) is that it forces you to confront the architecture and systems that underlie your own information consumption. Savvy librarians will know that our access to networked

information is mediated by dozens of invisible sources, from the unaccountable search algorithms that determine our starting (and often, ending) points, to the equally unaccountable censoring network "filters" that arbitrarily block whole swaths of the Internet, to underlying hardware and operating system constraints and choices that make certain kinds of information easy to consume, and other kinds nearly impossible.

In the automobile age, everyone was expected to know the fundamentals of how their cars worked. Even if you paid someone else to change your oil, it would take an act of will to attain adulthood in the USA without learning a bit about the mechanics underpinning the signal invention of your era. There were just too many ways that a car could go wrong, and too many ways that your life revolved around cars to rely on the rest of the world to understand them for you.

Now we live in the computer age, and if we thought we relied on cars, we hadn't seen anything. Some people spend so much time in their cars that it's like they live in them. But you literally do live inside a computer—a modern house, car, or institutional building is just a giant computer you put your body into. And modern hearing aids, pacemakers, and prostheses are computers you put inside your body.

Every part of our lives has been permeated by computers, and these computers have the power to peer into our private lives, to compromise our finances, to shape our political beliefs, to disrupt our families, and to destroy our workplaces. That is, if computers don't serve us, they can (and do) destroy us.

But for people who master networked computers and make them into honest servants, computers deliver incredible dividends. A UK study compared similar families, some with access to the 'Net and others without, and found that the families with 'Net access had better education, were more civically engaged and politically informed, had better jobs and income, were more socially mobile—even their health and nutrition were better. If computers are on our side, they elevate every single thing we use to measure quality of life.

So we need to master computers—to master the systems of information, so that we can master information itself.

That's where makers come in. One of the curious aspects of computers is that they evolve so quickly, they rapidly become obsolete. That means our communities are drowning in "e-waste," often sent to developing nations where children labor in horrific conditions to turn it all back into materials to be reintroduced into the manufacturing stream.

What if, instead of shipping our communities' "dead" computers to China to be dipped in acid by unprotected children, we brought them to our libraries. What

if we enlisted our makers to run workshops at the libraries, workshops where the patrons who come to the library to use the limited computers there were taught to build their own PCs, install GNU/Linux on them, and *bring them home*? People who say that it's dumb to turn libraries into book-lined Internet cafés are right.

Internet at the library should be the gateway drug for building a PC of your own, from parts to learning firsthand how computers work, what operating systems are capable of, and what locked-down devices and networks take away from their users.

Making a PC isn't hard, especially when you get the parts for free. The easiest way to get good at stuff is to make mistakes ("to double your success rate, triple your failure rate"). The best mechanic I know learned his trade by buying hundred-dollar junkers on Craigslist and destroying one after another until he got good (then *excellent*) at it. When you're building PCs out of literal garbage, you can do no wrong. Your failures just end up back in the same Dumpster they were headed for in the first place.

Look, we've got more computer junk than we know what to do with and a generation of kids whose "information literacy" extends to learning PowerPoint and being lectured about plagiarizing from Wikipedia and putting too much information on Facebook. The invisible, crucial infrastructure of our century is treated as the province of wizards and industrialists, and hermetically sealed, with no user-serviceable parts inside.

Damn right libraries shouldn't be book-lined Internet cafés. They should be book-lined, computer-filled information-dojos where communities come together to teach each other black-belt information literacy, where initiates work alongside noviates to show them how to master the tools of the networked age from the bare metal up.

My young adult novels always feature kids who build their own tools, in part because the coolest, most curious kids I know are already doing this. But it's also because this is a hobby that's available to anyone. The information is online, free. The raw materials aren't just free, they're worth *less than nothing*, a liability and a nuisance to be rid of. And the dividends are stupendous. Only through understanding the tools of information can we master them, and only by mastering them can we use them to make our lives better, rather than destroying them.

Cory Doctorow is co-editor of the popular weblog BoingBoing (boingboing.net), which receives over three million visitors a month. His science fiction has won numerous awards, and his YA novel Little Brother *spent seven weeks on the* New York Times *bestseller list. Canadian-born, Doctorow has held policy positions with Creative Commons and the Electronic Frontier Foundation and has been a Fulbright Fellow at the University of Southern California.*

LEONTINE SYNOR

Libraries are resources for those who otherwise would not have access to information due to finances, educational achievement, and other barriers. Libraries also serve as a safe space for those who are met with circumstances beyond their control, and provides them a place to learn, interact, ask questions and locate resources.

Trustee

EAST CLEVELAND PUBLIC LIBRARY

CLAIRE SCHMIEDER

I have always thought of libraries as a refuge—
as places to collaborate and learn. Libraries
offer people the freedom to be themselves.

Adult Services Librarian

CHERRY HILL PUBLIC LIBRARY

AMBER BILLEY

Libraries are part of the essential services in
every community. First responders save lives.
Librarians make lives.

Metadata Librarian

COLUMBIA UNIVERSITY LIBRARIES

INGRID CONLEY-ABRAMS

No one is better at fostering intellectual curiosity than children's and teen librarians.

Children's Librarian

BROOKLYN PUBLIC LIBRARY

CONNIE TUISKA

Libraries are sacred spaces because they represent a collective wisdom and are open to everyone.

Information Literacy Librarian

PALM BEACH STATE COLLEGE

LISA BUNKER

What does it mean in the twenty-first century to support learners, readers, dreamers, and makers? We're all trying to figure it out.

Social Media Librarian

PIMA COUNTY PUBLIC LIBRARY

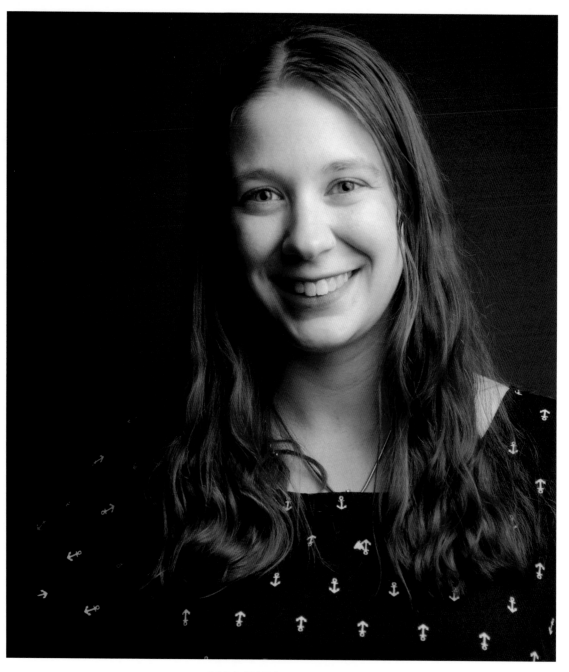

SARA MARGARET RIZZO

Libraries are for everyone. Access to information should be available for everyone, everywhere. Libraries are increasingly important, especially across Central Asia where Internet access is exploding. Librarians can help people learn to evaluate this new wealth of information, how to think critically about it, and to point them in the correct direction.

Humanities & Social Sciences Librarian/Expert Manager of Patron Services

CANDY MARKLE

Libraries can save your life;
libraries will set you free.

Librarian

SALT LAKE CITY /
SALT LAKE COUNTY
PUBLIC LIBRARIES

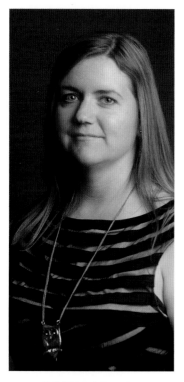

KATIE FORTNEY

Libraries and librarians are out there advocating for sensible copyright rules. We fight for the right to sell and lend the books and music you buy, and your rights to fair use. We're in the courts and in Washington, and sometimes we're the only ones in the room representing the interests of the public.

Copyright Policy and Education Officer

CALIFORNIA DIGITAL LIBRARY, UNIVERSITY OF CALIFORNIA

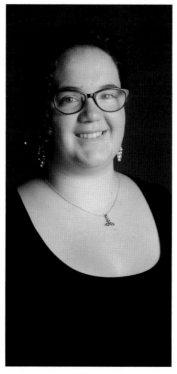

KJ GORMLEY

If the library shut down tomorrow in my tiny Maine town of two thousand people, people would actually freeze. The GED program wouldn't have a home, kids would be left to wander on Main Street until 5 p.m., shut-ins would lack a weekly visit with books, and any programs relating to the literacy, at any level, would cease. A good one-quarter of the town would have no access to the Internet. So, not nice things.

Assistant Librarian

LIBRARYTHING.COM

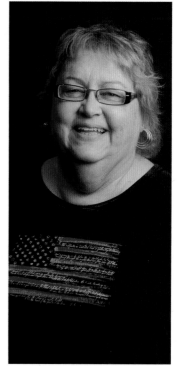

ROSANNE MILLER

I wanted to be a librarian since I was twelve. I've been a librarian for over thirty-five years and I love it. There's something new every day. Librarians rock!

Senior Library Manager

ORANGE PACIFIC LIBRARY AND HISTORY CENTER

To Serve Everybody

Nick Higgins, Rikers Island, and the Brooklyn Public Library

There is 23 more unhapy Prisoner at Portsmout and gosport . . . they wish to Know what to hope from you. For gods Sake have Compasion on those Stranger whos Property is all taken from them and they in Iorns No one to Comfort them, and it is not in the powe of the People to help them without You. You must be our Delivier our Salvation depends on you and you Sir have it in your Powr to Set us all in order. You may Set us all to work in Evry mans own way to help Each other to the good of the Whole which is the Prayr of your old faithful Servnt

> —*Letter to Benjamin Franklin on the plight of*
> *American prisoners in England from sculptor*
> *and spy Patience Wright, March 7, 1777*

After the Revolutionary War, Benjamin Franklin worked tirelessly on behalf of prisoners languishing under despicable conditions in England. Some were American sailors captured by the British, but many were the poor, locked up because of their inability to pay debts.

Franklin had some experience with early colonial jails. In 1722 his brother James drew the ire of officials after printing an editorial in his paper, the *New-England Courant*, critical of the government of Massachusetts for not doing enough to quell piracy in the Atlantic. It is, of course, far easier to jail loudmouths than it is to fight pirates on the high seas, so James was sent to prison amid conditions so deplorable that a doctor begged for his liberation lest he die. During this time Benjamin took over the business and became an actual printer for the first time, at age sixteen. Upon his release after four weeks, James was forced to agree to shut down his

newspaper and never print anything again without the supervision of the state. His younger brother used all this drama as an excuse to escape from Boston with four years left in his apprenticeship and journey to Philadelphia.

In 1729 Franklin began a series of articles in his own newspaper, the *Pennsylvania Gazette*, decrying prison conditions. And as a Quaker, the rights and treatment of prisoners was a subject never far from his thoughts. At a salon he hosted in 1787, a group of prison reformers, conspicuously and perhaps unimaginatively known as the Philadelphia Society for Alleviating the Miseries of Public Prisons, met. They agreed that America's penal system involved "inhumane punishments" and that prisoners ought, instead, to be given time to quietly reflect on their crimes. Dr. Benjamin Rush, a neighbor of Franklin's, suggested a "penitentiary" where people would learn to be penitent and leave prisons *reformed* rather than *punished*. These suggestions were implemented first at the Walnut Street Jail and culminated, thirty years later, with the construction of Eastern State Penitentiary.

It's probably not surprising that Benjamin Franklin also had a hand in creating the first prison library in 1790 at the Walnut Street Jail at 6th and Walnut Streets near Independence Hall. Early prison libraries optimistically tended toward religious treatises and volumes on self-improvement. Books went in both directions, though; life on the inside fascinated those on the outside. Even among the Philadelphia Society for Alleviating the Miseries of Public Prisons there was a sentiment that the full horrors of prison, if made known, would serve as a deterrent to crime. Popular literature of the time included the confessions of the about-to-be-executed, such as the *Declaration, Dying Warning and Advice of Rebekah Chamblit*, which styles itself as the final words of a twenty-seven-year-old Boston woman tried and executed in 1733 for infanticide. Whether she actually killed her child or saw it stillborn, and if she actually wrote her own *Dying Warning*, are a matter of some debate among scholars today, but the book is far from alone in the literature. In the late seventeenth century, Boston's most notorious Puritan, witch-hunter Cotton Mather had published a collection of last words of the executed under the title *Pillars of Salt*. As a child Franklin was influenced by Mather's *Essays to Do Good*, and although it's difficult to imagine two more diametrically opposed individuals, they both believed that people could reform and they both, at times, and certainly unintentionally, did more harm than good.

Despite his good intentions, Franklin's penitentiaries were miserable failures. Conditions at Walnut Street were described in 1799 with the publication of

The Narrative of Patrick Lyon: Who Suffered Three Months Severe Imprisonment in Philadelphia Gaol, on Merely a Vague Suspicion of Being Concerned in the Robbery of the Bank of Pennsylvania, with His Remarks Thereon. Lyon spent most of his time in solitary confinement. Here he lamented most the absence of intellectual pursuits:

> Under this long solitary confinement, I wanted books (divested of any other amusement), to pass away my time; I at length got the Bible and Robert Burns's Scotch poems, which made my library as complete as was in my power to collect. I read until I was tired, and walked till I was weary, every day expecting that my releasement would come; and although I am, and have been, very much given to professional study, I could not study the grand science which I have made so much progress in (considering my age) embracing every opportunity to do so.

Lyon spent much of his time begging prison officials for, and being repeatedly denied, pen and paper not just to keep a record of his time in jail, but also to prepare for his trial and correspond with friends.

The Quaker prison reformers had imagined that prisoners, spending most of their time alone in a room the size of a rowboat, would read the Bible, reflect on their crimes, and perform "honest work." As Lyon discovered, however, the penitentiary was far from the model of quiet decency its founders had hoped. Over the next 150 years its critics were many, and the experiment became known to be a colossal failure. Novelist Charles Dickens visited Eastern State in 1842 and found it monstrous. He held that such forced solitude and idleness was "immeasurably worse than any torture of the body." The prison closed in 1971. Walnut Street preceded it, shutting its doors in 1835.

The American Library Association has long been an advocate for a prisoner's right to read and encourages local libraries to extend service to jails and detention facilities within their jurisdictions. This can be a hard sell in communities that are already cutting funding to libraries on the outside.

In 1974 Justice Thurgood Marshall eloquently wrote in *Procunier v. Martinez* [416 US 428 (1974)]:

> When the prison gates slam behind an inmate, he does not lose his human quality; his mind does not become closed to ideas; his intellect does not cease to feed on a

free and open interchange of opinions; his yearning for self-respect does not end; nor is his quest for self-realization concluded. If anything, the needs for identity and self-respect are more compelling in the dehumanizing prison environment.

The state of prison libraries is much advanced from Franklin's time, yet there are still opportunities for discovery.

Nick Higgins wanted to be a rare-book librarian until he was stationed in Brownsville, Brooklyn, and a woman walked in with a letter, explaining that her son was in prison somewhere in New York State and she needed help finding where he was. In that instant all thoughts of white gloves and musty artifacts left his mind and he realized that his calling was helping to connect parents and children.

Nick is currently the director of outreach services for the Brooklyn Public Library. These services fall into three groups: immigrant services, services for older adults, and transitional services. Transitional services focus on providing library services for people who are in jail, coming out of jail, living in homeless shelters, or returning veterans.

"There is no [city] mandate," says Higgins, "to have library services in our city jail. Our city jail is Rikers Island, which consists of ten jails, two borough-based facilities, plus a floating barge. So there's really no access to any general library services. If we weren't doing it, people wouldn't have access to any library. We are the public library; our mandate and our mission—and it's a very noble one—is to serve everybody no matter where they live."

According to a 2010 report from the Pew Charitable Trusts in that year there were 2.7 million American children with at least one parent in jail or prison. Visits are difficult because of time, location, limited hours, and an inhospitable environment. Making it easy for prisoners to see their families is extremely low on a correctional facilities "accomplish today" list. They don't get business from rave customer service reviews on Yelp; their primary responsibility is to keep people from getting out. As a result, most incarcerated parents don't receive visits from their young children. Nick's first attempt at providing some parental normalcy was a 2010 program called Daddy and Me, which involved videorecording incarcerated parents reading to their children and delivering a DVD to the child. The pilot program was successful, and Higgins was able to roll that attention into a broader program.

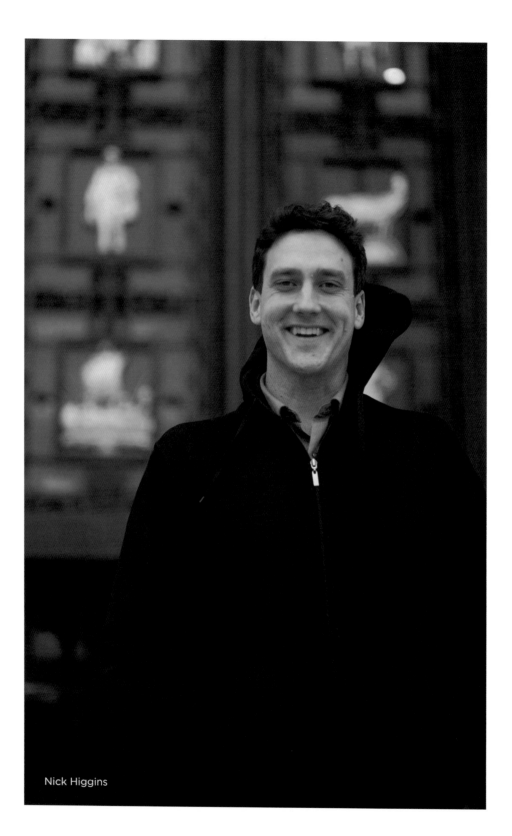
Nick Higgins

"We're looking to connect families," he says, "especially people who have parents who are in jail, so we try and connect the kids with their parents. We just launched this broad initiative with Cisco Systems and the New York Society for Ethical Culture and the city department of corrections. Cisco gave us a videoconferencing system to set up in our central library, and what we do is invite families and kids primarily to sit down and read a book with their incarcerated parent. It's one of those things where you create a moment between parent and child, which kind of reflects what the library does anyway. But it means so much more in this particular instance because of the physical separation of the parent and child is so great. And we can facilitate that meeting between parent and child in a very meaningful way."

In helping parents in difficult circumstances connect with their children, Nick is building new and positive stories about libraries.

"I've always thought it was important to serve folks who were incarcerated," says Higgins, "because there's no better way to further the mission of the public library than to fight to get access to information and reading materials and library services in a place that's downright hostile to getting information. So every day that I go to work, I feel that I'm living the mission of the public library. We demonstrate how civil society should work; we look out for somebody by giving them something or giving them information with the implicit understanding that they're going to return the favor, they're going to talk about it, and they're going to return the favor to the next person in line. It's wonderful. It's the best job I've had at the library."

JOHN MYERS

There is no time in which I would rather be a librarian than today . . . unless it is tomorrow. We have never lived in a time where the data, information, resources, and tools exist to meet people's needs and in which our abilities to navigate them are more vital.

Catalog Librarian

SCHAFFER LIBRARY,
UNION COLLEGE

KATY HOLDER

My library is the only place in my town where people can get help signing up for unemployment. We do résumés, computer training, provide information on shelters and emergency help when things are at their worst.

MLIS Student/Reference Assistant

UNIVERSITY OF
SOUTH CAROLINA /
YORK COUNTY LIBRARY

MIRANDA NIXON

I'm a preservation librarian and I don't think most library users consider how a print collection or a digital collection is maintained and preserved. When I lead tours of my department or explain what I do, people are always surprised.

Preservation Coordinator

UNIVERSITY LIBRARY SYSTEM,
UNIVERSITY OF PITTSBURGH

SANDRA CHILDS

In my school library the most important thing that I do is connect students and teachers to as much of the big, beautiful world that I can, in as many ways as I can, including through a visit from a graphic novelist, hosting a city-wide poetry slam, teaching kids to access databases, coaching kids on college essays, writing, talking up a memoir, demonstrating a cool app, promoting story through social media, leading a workshop on making a movie. Officially my job is to help kids locate, evaluate, use, create and share information. Unofficially I teach students to use and celebrate their voices and how to read the word and the world.

Library Media Specialist & Teacher-Librarian / LMS
FRANKLIN HIGH SCHOOL MEDIA CENTER

PEARL LY

I am a college library administrator because I want to support student success and open access to higher education. I want to build and sustain high performing and amazing libraries. I am inspired by my father who was a Vietnamese boat person immigrant and still hopes to go to community college before transferring to a four-year college to complete a degree.

Library Director
SKYLINE COLLEGE

JOHN JACKSON

Librarians offer so many opportunities for so many people from so many walks of life. As a college librarian at a small institution, I have the opportunity to teach students to think critically, to think beyond their own experience, and put themselves in others' shoes. I teach them to live as a community.

Outreach and Communications Librarian
LOYOLA MARYMOUNT UNIVERSITY

OSCAR LANZO-GALINDO

I do this work because I love it, and because I want my daughter to be proud of the legacy we leave her generation. Someday, whatever she decides to do, I hope she has the same passion.

Library Director
DONALD B. WATT LIBRARY
& INFORMATION COMMONS

DANIELLE EHIO

The most important services libraries provide are the programs they put on for the community. Programs provide the community with chances to explore both the library and the community they belong to. They are an interactive way to bring literacy to the community.

Librarian
SAN DIEGO PUBLIC LIBRARY

CRYSTAL BOYCE

Big data is scary right? No. It doesn't have to be. All you need is a librarian on your side. Looking for patterns in information is what we do. As access to large data sets become easier, librarians are going to do what they've always done— connect users with information and help make patterns visible.

Sciences Librarian
ILLINOIS WESLEYAN UNIVERSITY

NATALIE KORSAVIDIS

Libraries help introduce children and teens to the wonderful world of literature. There is nothing I enjoy more than seeing a teen's face when they connect to a book—it's magical.

Head of YA
FARMINGDALE PUBLIC LIBRARY

LYDIA WILLOUGHBY

We are here for you! Come on in!

Research and Education Librarian

SUNY, NEW PALTZ

DANIELLE MILAM

Your education and success is our business.

Development Director

LAS VEGAS–CLARK COUNTY LIBRARY DISTRICT

BRIAN HART

Libraries are the connective tissue of the community; connecting people with the resources they need and want in order to do, see, and be all they aspire.

Children's Services Manager

CHARLOTTE MECKLENBURG LIBRARY

KARLA CARRILLO

Libraries are a gateway to knowledge. Smart is the new cool.

Volunteer Coordinator /
Outreach Librarian

SAN DIEGO PUBLIC LIBRARY

Jeff Vandermeer

The first librarian I knew was Meredith Ann Pierce, who worked at the Gainesville Public Library. She was the smartest person I knew, and the coolest—along with being a librarian, she *also* wrote fantasy novels that were smart, exciting, and brilliant. A lot of people whom she helped in the library didn't know she was a writer, and it wasn't that Meredith was a writer pretending to be a librarian—she clearly loved the librarian work. She was and is a great person in all ways; a person who was of use to a lot of people who came into that place and who also nurtured young writers. I went a few times to the library when I was a teenager to receive the latest critiques of my stories from her. She'd take time on her break to give me guidance—truly great advice. It didn't hurt that the Gainesville Public Library, (which was refurbished in 2008), with its huge central dome, had become an amazingly modern yet cozy and old-fashioned space that inspired the imagination. In fact, one of my first professionally published stories, "Greensleeves," is set in a library very much like it. Ever since, I've found libraries to be places that evoke for me fond memories of learning and of a kind of beauty. And a librarian, obviously, was crucial to my development as a writer.

Jeff Vandermeer is the New York Times *bestselling author of more than twenty-five books, including the Southern Reach trilogy.*

MOLLY HIGGINS

Not all libraries work with books. I work with medical journals. My colleagues work with data. We teach and help medical students, doctors, and researchers how to do research better. Sure, we still have books, but that's not what our job centers on. At the center of our profession is giving direction to curiosity.

Library Fellow
UMASS MEDICAL SCHOOL

KELLY STADE

Libraries empower people to be their
true selves.

Library Services Manager
HENNEPIN COUNTY LIBRARY

DORLISSA BEYER

We are not quiet people.

Library Assistant
HASTINGS PUBLIC LIBRARY,
HASTINGS, NE

NATALIE DEJONGHE

Libraries mean that no matter what your situation, you will always have a place where you can go to find the knowledge you need to be the person you want to be.

Ebook Trainer / Grant Project Coordinator

REACHING ACROSS ILLINOIS LIBRARY SYSTEM

STEPHANIE BEVERAGE

When I was growing up I always saw the library as a refuge, a launch pad, and an oasis. I want to make sure others have the same opportunity to experience the magic of the library.

Library Director
HUNTINGTON BEACH PUBLIC LIBRARY

The Little Library That Tried

Mary Anne Antonellis and the M. N. Spear Memorial Library

SHUTESBURY, MASSACHUSETTS

The story of the M. N. Spear Memorial Library in the small town of Shutesbury, Massachusetts, is not unusual. It started with a few high-minded citizens hoping to better the nature of the town and over the years involved the generous input of a few individuals.

The current library structure, located on a hill along a quiet road surrounded by trees, was built in 1902 with a $1,571 bequest from Mirick Spear, a Shutesbury native who moved to nearby Amherst but retained his close ties with the town. He died in 1900. Prior to Mr. Spear's bequest the library existed as a single bookcase.

The first librarian, Mary Clarke, was the housekeeper of one of the town's selectmen. She kept the library open two hours a week. In the 1930s William Spear, Mirick's son, donated forty-five shares of AT&T stock to the library to keep it running. This stock remains in trust today.

The Spear library is small, at nine hundred square feet, and initially so was the town. In 1970 the population of Shutesbury was 489 people; twenty-five years later it was nearly four times that size. While the size of the library hasn't changed, it has begun to innovate.

In 2013 library director Mary Anne Antonellis saw a grant opportunity from Redbox, the video rental company, to convert underutilized outdoor areas to community spaces. Antonellis knew of just the place: an area along the shore of Lake Wyola, which the town previously maintained as a public beach until the state opened up its own on the other side. With the exception of some library-sponsored

GPS scavenger hunts, the parcel of land hadn't really been used since. Why not put it to work full-time? Why not get a bunch of kayaks and station them on the old town beach so that people could explore the lake without having to own a boat, or transport it to the lake?

The town loved the idea. Redbox did, too, and came forward with enough money for three kayaks and a rack to secure them as well as furniture so that people can sit by the lake and watch those responsible individuals with no library fines as well as the good sense to plan ahead paddle around. These days during the summer the kayaks are almost always loaned out all weekend and most of the week.

The library also innovated with ebooks. OverDrive, a national lending platform company, as well as the Commonwealth of Massachusetts's own ebook projects Axis 360 and BiblioBoard, all provide content that patrons can check out on their mobile devices. The library is instrumental in bringing the world to Shutesbury, where there is no high-speed Internet and no cable TV. When the switch from analog to digital TV happened, many people in town lost television altogether,

Rather than be limited by the size of her building, library director Mary Anne Antonellis started the kayak loan program with a grant from Redbox.

which makes the library's collection of DVD movies and television shows very popular. They also provide free wireless; on any given day there are cars parked outside with people working on laptops in their passenger seats, because innovation alone couldn't make up for the fact that the library is only large enough to accommodate (apart from two computer stations) three chairs, none of which have table space.

Nine hundred square feet just wasn't cutting it for the needs of the library, which is the fourth busiest in the commonwealth among towns of comparable size. So in the mid-1990s the town started talking about getting a larger and more functional building. The existing building had no running water, not to mention a heater that spewed volcanic drafts up through a single metal grate in the floor and was known to melt patron's shoes if they stood in the wrong place for too long.

The nine-hundred-square-foot M. N. Spear Library in Shutesbury.

Shutesbury's video attracted a lot of high-profile attention from authors around the world as an example of what's happening in communities everywhere.

The state of Massachusetts offered $2.1 million if the town could provide $1.4 million in matching funds, paid over twenty years. But the proposed tax burden of about eighty dollars a year per household set Shutesbury into a frenzy of acrimony and hatred that turned neighbor on neighbor in a way historically rarely seen on the same side of the Mason-Dixon Line. Residents devolved into their basest selves, and town meetings into furious internecine battles. So vituperous and contentious was the rhetoric that the elementary school principal forbade students to discuss it.

"What a bunch of dopes!" said one commentator on the news website MassLive .com, encapsulating what many people believed about libraries. "They most [sic] live in the Fifties . . . Or are they ignorant of the digital revolution! Ebooks [sic] Readers don't need a shelf!! Maybe they wanted a meeting place for yoga and basket weaving. Put up a tent!"[2]

The library does indeed offer yoga classes, as well as live animal programs, science demonstrations, picnics, book clubs, and nature walks lead by botanists. The proposed library space would also have included a public meeting room, which the town lacks; the fractious assemblies discussing the new library had to be held in the school gymnasium.

Whether or not the town would borrow the $1.4 million, build a library, and raise everyone's taxes hinged on a single vote held in January 2012. With 74

[2] http://www.masslive.com/news/index.ssf/2012/01/shutesbury_registrars_in_recou.html

percent of the eligible voters coming out to cast a ballot (16.5 percent higher than the percentage of Americans who cast a vote in the presidential election that same year), the result was an unbelievable and excruciating tie: 522–522, with a single uncounted provisional ballot cast by a voter without ID.

Citizens retreated to their corners, licked their wounds, and sharpened their spears. When the provisional ballot was authenticated and opened, library supporters let out a cheer: The library had won by a single vote, 523–522. Opponents immediately filed a lawsuit challenging the legitimacy of eight ballots; library supporters filed a countersuit, challenging three ballots of their own. After a flurry of legal activity that kept local journalists furiously turning pencils into sawdust for months, judges finally threw out two of the yes votes, making the vote 521–522 against the library with no time left for an appeal.

Kayak lovers scrambled to raise the money themselves, with the help of a viral video that was shared by some high-profile bibliophiles, including novelist Cory Doctorow and comedian Paula Poundstone, but it was too late. As the deadline approached, the proposal for a new library was DOA.

When the dust cleared, library supporters wiped up the blood, counted their blessings, and planned for the long game. The money they raised independently is in the bank, and the town has appropriated twenty-five thousand dollars a year for them every year since to save for a new building. There's also a new round of grant funding applications coming up in a few years, and they'll give it another shot. And until then, there are the kayaks.

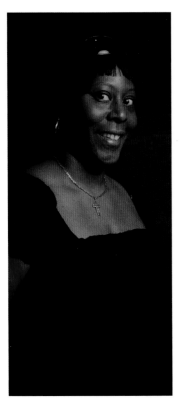

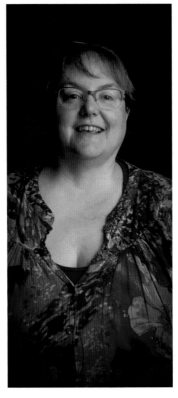

SIMONE L. YEARWOOD

In spite of the Internet, libraries are relevant. In fact due to the Internet there is a much greater need for librarians to assist users to get through all the clutter in cyberspace.

Access Services Librarian
CUNY QUEENS COLLEGE

ANN MORGESTER

Libraries are now, as always, about access, creativity, and literarcy. The school library is an equalizer for all students; a safe space to create and explore, and the best place to find your new favorite books.

Library Supervisor
ANCHORAGE SCHOOL DISTRICT

ASHLEY FEJERAN

Access to information builds community. Especially when people have access to, and a place to share, their histories and lived experiences. For minority and underserved populations this is especially critical.

Digital Projects Tech
PORTLAND STATE UNIVERSITY

ANGELA BARRETT

One thing children's librarians do that most people don't realize is provide caretakers with the skills and tools to engage their kids. School takes up a very small percentage of children's time and a little time spent at home and the library can make a big difference.

Children's Librarian
LEBANON PUBLIC LIBRARIES

JOVANNI LOTA

My name is Jovanni Lota, but most people know me as the Librarianista. I am the Information Literacy Coordinator Librarian at the University of Houston-Downtown (UHD). As the supervisor for the instruction department, I coordinate all of the library's instruction sessions, First-Year Experience orientations, and also oversee all of our instruction-related assessment efforts with the help of two other librarians under my direction. We have such a dynamic team of instruction librarians; we excel at creating exciting and engaging activities for our students, faculty, and staff. We focus on using popular culture as a means to attract our students to the library, and have had great success with that approach.

Information Literacy Coordinator Librarian
W.I. DYKES LIBRARY,
UNIVERSITY OF HOUSTON — DOWNTOWN

ANDREW WERTHEIMER

I knew I was on the path to becoming a young man when my librarian took me to the adult nonfiction section to help me answer a difficult question. I'll never forget that moment; going from the warm, safe space of story times into the world of adult responsibilites. I hope libraries will continue to thrive as places of dreamlike escapes as well as paths to literary and global citizenship.

Associate Professor of Library Science
UNIVERSITY OF HAWAII
AT MANOA

SHANA L. McDANOLD

When I'm asked what I do for a living, I answer that I make stuff findable. If the semantic/social web (and linked data) is teaching and showing the world anything, it's that keyword isn't enough. We need to describe the stuff out there, and then pair it with controlled data so that links can be made. That description and controlled data is what metadata and cataloging librarians specialize in. We organize it and make the stuff of the world findable.

Head, Metadata Services
GEORGETOWN UNIVERSITY

KIMBERLY GRAD

I have been a children's librarian since the age of ten, but it took me several years to get to the point where I am working now, at Brooklyn Public Library. I am inspired by my work with children. I have led numerous story time classes and hosted many class trips to the library and I hope that my enthusiasm for reading will be an inspiration to children of all ages!

Coordinator, School Age Services
BROOKLYN PUBLIC LIBRARY

MARI MARTINEZ SERRANO

It inspires me when Spanish speakers and Latinos walk into the library and their eyes light up. It's like they are discovering a new world. It still amazes me that for the amount of Latinos and Spanish speakers in the US there is still a huge gap of services, literature and LIS professionals in libraries, to better serve them. We keep talking about diversity like it was a latest trend, but we need to move the talk into action. As a Latina current LIS student and a ACA emerging leader, I want to act and tell the story for our side. If there is no minority leadership in the "poll" how is diversity ever going to happen?

Spanish Services
ST. HELENA PUBLIC LIBRARY

ERIN BERMAN

Libraries are centers for knowledge that everyone
in our society can access. They provide a place for
discovery, creation, and innovation. Libraries are
our future; without them our democracy is lost.

Librarian

SAN JOSE PUBLIC LIBRARY

John Scalzi

The first library I remember ever visiting was the library in Red Bluff, California. I was five at the time, and living with my aunt while my mother was recovering from surgery. I remember the children's area of the library, and in my recollection of the place today, the rows of books went all the way up to the ceiling. I remember specifically, although not by name, a picture book I pulled down from the rows, about children leaping for the moon. It was explained to me that I could take the book home—and not just *that* book, but *any* book I wanted in the *entire* library. I remember thinking, in a five-year-old's vocabulary, *How unbelievably perfect*. I took home a book about stars, which started a lifelong love of astronomy.

The second library I have a strong memory of was the Covina Public Library, in my then-hometown of Covina, California. My mother and then-stepfather worked all day; I would walk or bike to the library most afternoons, reading magazines and looking through reference and trivia books. I also remember specifically spending a lot of time with a book about dragons.

I remember the library at Ben Lomond Elementary School, also in Covina. It was there I first made the acquaintance of Robert Heinlein, in a library-bound edition of *Farmer in the Sky*. It was the start of a beautiful relationship.

At the West Covina library, I discovered that I could borrow LPs and listen to them at turntables in the library! I remember sitting in a chair, next to a turntable, headphones on, listening to Bill Cosby LPs and giggling as quietly as I could (it *was* a library) while simultaneously flipping through a Time Life book called *Planets*, written by one Carl Sagan.

The library in Glendora was where I stayed in the afternoons when my now divorced mother worked. I would sit just outside the kids' area, eating Jujyfruit candies (you could buy a whole big box for forty-nine cents at the Ralph's just down the street), reading what were called juvies then and are called Young Adult books now. It was the first place I was exposed to a real live computer: A TRS-80 Model III. I remember programming the computer in BASIC to play simple games. It was there I met Mykal Burns, who was (and remains) one of my best friends. I also met—*actually* met, not just in a book—Ray Bradbury there, which to me was something like meeting a wizard.

The library at Sandburg Middle School is where I would be in the early morning before school started, reading science fiction and rushing through my homework. It was also the scene of some of my greatest junior high triumphs, as I participated in schoolwide "science bees" staged there, for the Red team (the school divided alphabetically into colors), and would single-handedly *utterly slaughter* entire opposing teams. All those years of checking out trivia and science books paid off with a vengeance.

At the Thomas Jackson Library at the Webb Schools of California I met Dorothy Parker, Robert Benchley, James Thurber, Harold Ross—heck, the whole of the Algonquin Round Table—plus Ben Hecht, H. L. Mencken, P. J. O'Rourke, Molly Ivins and Hunter S. Thompson, Tom Stoppard and George Bernard Shaw. In the science-fiction section I was introduced to Robert Silverberg, Larry Niven, and Ursula K. LeGuin. Here was where I discovered many of the writing idols of my youth.

The University of Chicago unsurprisingly had many libraries; the one I spent the most time in was the Harper Library, where the university kept most of its fiction. The space these days would remind people of Hogwarts, I suppose; at the time I thought of it like a cathedral, filled with books, and also very comfortable cushions to read (and, sometimes, nap) on.

When I left the University of Chicago, my relationship with libraries changed, because my position in life changed. I had a job and money, and for me that meant I could *buy* books. So I did: I bought new books by the authors I was introduced to in the library, and bought the old books I'd checked out so many times *from* the library, because now I could afford to own them. I bought books on the subjects I first became interested in by wandering through the library stacks. I bought as gifts the books I had grown to love and wanted others to love, too. I had become a fervent buyer of books because libraries made it easy to become a fervent reader of books—to make them a necessary part of my life. For about a decade I didn't use the library much, because I was in the bookstore. It was a natural progression.

I remember the library in Sterling, Virginia, because that was where I lived when I got my contract for the very first book I would have published: a book on online finance. As part of my research for the book, I went to the library and checked out just about every book on finance they had, to see how those authors had written on the subject, and to make sure I didn't have any obvious gaps in my own knowledge of the subject. When it was published I went back to the library and was delighted to find my new book there, too. And it had even been checked out! More than once! I felt like a real author.

Finally I arrive at my present library, the one in Bradford, Ohio. It's a small library, but then, Bradford is a small community, of about eighteen hundred people. For that community, the library holds books, and movies, magazines, and music; it has Internet access, which folks here use to look for jobs and to keep in contact with friends and family around the county, state, and country. It hosts local meetings and events, has story times and reading groups, is a place where kids can hang out after school while their parents work, and generally functions as libraries always have: as a focal point and center of gravity for the community—a place where a community knows it *is* a community, in point of fact, and not just a collection of houses and streets.

I don't use my local library like I used libraries when I was younger. But I *want* my local library, in no small part because I recognize that I am fortunate not to *need* my local library—but others do, and my connection with humanity extends beyond the front door of my house. My life was indisputably improved because those before me decided to put those libraries there. It would be stupid and selfish and shortsighted of me to declare, after having wrung all I could from them, that they serve no further purpose, or that the times have changed so much that they are obsolete. My library is used every single day that it is open, by the people who live here, children to senior citizens. They use the building, they use the Internet, they use the books. This is, as it happens, the exact opposite of what *obsolete* means. I am glad my library is here and I am glad to support it.

Every time I publish a new book—every time—the first hardcover copy goes to my wife and the second goes to the Bradford library. First, because it makes me happy to do it: I love the idea of my book being in *my* library. Second, because that means the library doesn't have to spend money to buy my book, and can then use it to buy the book of another author—a small but nice way of paying it forward. Third, because I wouldn't be a writer without libraries, hard stop, end of story. Which means I wouldn't have the life I have without libraries, hard stop, end of story.

I am, in no small part, the sum of what all those libraries I have listed above have made me. When I give my books to my local library, it's my way of saying: Thank you. For all of it.

And also: Please stay.

John Scalzi is best known for writing science fiction, including the New York Times *bestseller* Redshirts, *which won the Hugo Award for Best Novel. He also writes nonfiction on subjects ranging from personal finance to astronomy to film, and was the creative consultant for the* Stargate: Universe *television series.*

VALERIE BOGERT

Not only do I provide books to my littlest patrons, I help their parents learn how to parent. I help them find materials on potty training, behavior, education, life development stages, and much more.

Youth Services Librarian

SPRINGFIELD GREENE COUNTY LIBRARY

KIRK MACLEOD

Libraries are the one place where you can go to ask anything and instead of simply getting a list of related stuff, you will find a librarian excited to help you find whatever you need. That excitement alone is well worth the trip.

Open Data Coordinator

GOVERNMENT OF ALBERTA, CANADA

ALICIA LONG

For many immigrants to this country, the library is the first place where they feel accepted. Library services to Latinos and the Spanish-speaking community is an area of which librarianship, as a field, should be proud. Nothing beats the feeling of walking into a library as a newcomer or an English-learner and hearing a welcoming message: A smile and a *Bienvenido*!

Reference Librarian
STATE COLLEGE OF FLORIDA

TAWNYA SHAW

The Internet has not automatically granted free information for all. Over half of all Americans still do not have Internet access at home. Many families cannot afford books or magazines or tutors. Libraries offer these services, and many more, for free. Parents can take their children for free story time or access free databases for homework. Job seekers can receive one-on-one training and free résumé help. Community groups can gather together for free. The existence of the Internet does not make libraries or the services they provide irrelevant, it makes them more important than ever.

Virtual Librarian
HENDERSON DISTRICT PUBLIC LIBRARIES

KRISTEN CURE

My experience in the Peace Corps working with subsistence farmers in rural Nicaragua inspired me to become a public librarian. The lack of free access to information and quality education created so many obstacles. Libraries, especially public and school libraries are essential to a healthy democracy. Free access to information gives people the ability to develop a lifelong love of learning and the tools to better their lives. This has allowed our democracy to flourish. Librarians have become such a part of our lives in the United States that it is easy for us, as a society, and take them for granted.

Latino Liaison Librarian
SPRINGFIELD PUBLIC LIBRARY

NICOLA McDONALD

I like my job because I get to make a positive impact in people's lives every day! Whether advocating for teens and offering them mentorship, conducting readers, advisories, or going outside my comfort zone to do a story time. Libraries have such a unique role in communities because we do so much. And, I'm glad to be a part of that!

Library Manager
NEW YORK PUBLIC LIBRARY

ERICK TOUSSAINT

Libraries are important for getting people to gather and share community values. Their openness to the world facilitates communication and knowledge. Many people cannot afford technology or access to the Internet. We need the library to help with that. Without libraries there would be a radical decrease of academic performance, less connection among people of the community, no more space for expression or learning of new skills.

Library Program Coordinator
FOKAL (FOUNDATION FOR KNOWLEDGE AND LIBERTY)

KATIE LEWIS

I want to nurture curiosity, feed knowledge, lay the foundation for information.

Library Science Student
DREXEL UNIVERSITY

LES ARMS

People need libraries because people need places that let them read what (and how) they want to read.

STEM Librarian
UNIVERSITY OF TEXAS

TEGAN DAVIS

Librarians can be the bridge that transforms your life.

Youth & Spanish Services
PARK CITY LIBRARY

The Calvin Coolidge Presidential
Library exists as a separate entity
inside the Forbes Library.

History You Can Hold

Julie Bartlett Nelson and the
Calvin Coolidge Presidential Library

NORTHAMPTON, MASSACHUSETTS

George Washington doesn't have a federally funded presidential library. Neither does Thomas Jefferson or Abraham Lincoln.

The Presidential Libraries Act didn't pass until 1955. Before then, most presidents had taken their papers with them when they left office. Ultimately these records were scattered among interested parties or, in many cases, burned.

Herbert Hoover is the first president with a library supported by the National Archives and Records Administration. Other libraries are not officially sanctioned by the National Archives, but they exist. Presidential belongings have been collected after the fact. Washington's papers, scattered at the time of his death, have been painstakingly hunted down, copied, and digitized over the past fifty years and are available online, for free, through the efforts of the University of Virginia. But Washington was a unique figure; other presidents have not fared so well. There is no Millard Fillmore presidential library, apart from the bar with that name in Cleveland. The State University of New York's Buffalo campus has "one linear foot" of documents in their Millard Fillmore Papers collection. Oswego State University (also part of SUNY) has another set of letters that were found in two wooden boxes in an abandoned house, but there's no one-stop shopping.

Calvin Coolidge thought ahead and started giving his papers to the Forbes Library in Northampton, Massachusetts, in 1920 while he was vice president. In the 1950s his wife, former First Lady Grace Coolidge, encouraged the commonwealth to establish a "memorial room" that could contain other items dedicated to the collection in the town where he lived, worked, and served as mayor.

Today presidential libraries are privately funded multimillion-dollar monuments to vanity paid for by friends and people who want to make a good impression. While they house documents of interest to scholars, their main purpose is to serve as museum exhibits for the general public. Building them is expensive and gives ex-presidents something to fret about for a few years instead of constantly being on television, opining about the Middle East, and worrying their successors.

The National Archives support fifteen libraries for thirteen presidents (Gerald Ford and Richard Nixon somehow got two each) starting with Franklin D. Roosevelt and ending with George W. Bush at a cost to maintain of about seventy-five million dollars per year. The Obamas have plans for one on the South Side of Chicago; breaking with tradition, it will be called the Obama Presidential Center, instead of library, perhaps a more honest name for an institution that will likely labor to continue the president's political ideals. And to be sure, all of the recent presidential libraries are designed to be cheering stations for the person whose name is on them. In his book *Presidential Temples: How Memorials and Libraries Shape Public Memory*, historian Benjamin Hufbauer points out that the Reagan library doesn't mention the Iran Contra scandal and Kennedy's doesn't talk about his extramarital affairs. (The Clinton Library includes short mention of the Monica Lewinsky scandal, buried in one of fourteen alcoves, titled *The Fight for Power*.) However, any archivist at the Smithsonian would point out that before the Presidential Recordings and Materials Preservation Act of 1974, presidents were free to simply destroy any records they didn't want people to see.

The Ronald Reagan Presidential Library houses both Air Force One and, excessively it seems, an actual Irish pub from Ballyporeen, Ireland, that the president visited in 1984 to drink a pint of Smithwick's ale. The Calvin Coolidge Presidential Library contains nothing so opulent but does have several of Silent Cal's hats, the desk from his law office, and in the archive room I noticed a box labeled GAVELS. Coolidge's library is the only one housed within a public library and as such exhibits the flair for multipurpose use that public libraries are accustomed to; on the day I planned to visit, a ukulele group was scheduled to practice there, it being the library's largest space and having excellent acoustics.

The Coolidge collection is overseen by archivist Julie Bartlett Nelson, who's there to help scholars find documents in the tidy collection of letters, manuscripts, scrapbooks, personal papers, microfilm, and various audio and video recordings. Julie is the library's sole paid employee, and on top of that she's part-time. The

chasm between this and the visitor experience of getting your photo taken standing at the open door of President Reagan's Boeing 707 in a ninety-thousand-square-foot glass hangar or standing in an exact replica of the Oval Office in Simi Valley, California, is deep. All pre-Hoover presidential libraries are neither controlled nor funded by the federal government. They rely on funding from universities and corporate and individual donors. A task that's easier to accomplish if you're the Abraham Lincoln library than it is if you're the Benjamin Harrison library, whose research archives are open by appointment only.

Politicians often say they want to help libraries, but there can be a hidden or not-so-hidden subtext to this vow. Mark Antony showed up in Egypt with two hundred thousand scrolls as a gift for Cleopatra's library, but he'd destroyed the Library of Pergamum to get them. He wasn't interested in donating to the library at Alexandria; he was interested in borrowing the Egyptian navy to fight Octavian. Presidential museums and archives sometimes exist at cross purposes. And at the same time, it's difficult to expect politicians to raise millions of dollars to create monuments dedicated to their greatest failures. The Nixon Library does contain an exhibit on the Watergate scandal, but it was installed only after a yearlong battle between the Richard Nixon Foundation, which controlled the museum, and the national archivists. No library's foundation has any influence on access to records,

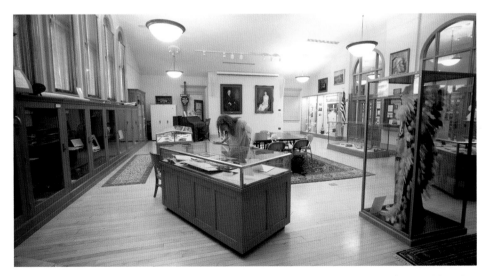

The Coolidge library's Memorial Room houses a Sioux headdress given to the president in 1927 when he was adopted into the tribe in a ceremony at Fort Yates in North Dakota.

though it does have an impact on things like exhibits and additional collections brought into the library. Access to documents, however, is provided through the National Archives, independent of the museum foundations.

Being completely private has advantages. Julie points out there are no restrictions on whom she can allow to let see what, which might mean that schoolchildren get to hold an actual letter written by an actual president in their hands or that a history enthusiast who's not working on an official project can use resources another presidential library may forbid. But being controlled by a private board also means that the future safety of the documents is in the hands of those people. Thus far the board members overseeing the Coolidge collection have been "very responsible and take their responsibility to preserve those documents very seriously," according to Janet Moulding, the director of the Forbes Library that houses the Coolidge collection, but there are no governing protections in place for the handling and future of those documents. At issue today, when funding is controlled by political allies of a living politician, is the freedom of archivists and curators to exhibit unflattering material about a president. In his paper "America's Pyramids: Presidents and Their Libraries," Richard J. Cox, from the Department of Library and Information Sciences, University of Pittsburgh, referred to current presidential library system as "not an effective advocate . . . for the openness of government records" and suggests that all presidential papers belong in one national archive, "allowing greater independence from the interference by the former Presidents,

President Coolidge's hats. Presidential libraries are treasure troves for film crews trying to re-create the smallest details.

Presidential campaign ribbons from the 1924 Republican convention are among the items in the presidential library.

their heirs, or their protégés." Cox wants the museum aspect done away with, or at least reduced, and the emphasis to be on documents, leaving the various museums of Washington to concentrate on exhibits.

The disparity between self-funded presidential library/museums created by political allies and libraries put together by academics, archivists, and librarians is vast. At the Coolidge library Julie divides her time between giving informal tours of the four-thousand-square-foot museum and exhibit space, and assisting scholars, historians, and interested individuals looking for items in the research collections, which include four thousand photographs, as well as primary and secondary sources.

Julie, as she says, presents programs "for ages zero through one hundred." Schools visit the library, and Julie visits schools as well as retirement communities and senior centers. On the third Thursday of every month "Cookies with the Curator" is held: The library brings out objects around a particular theme for people to see and discuss.

What's the difference between celebrating and camouflaging history? There are no lines at the Coolidge Presidential Library. And if you think you can dig up a scandal in Coolidge's scandal-free administration, you're not going to have to get a FOIA request to get the documents you want (although an archivist will point out Coolidge had all the time and none of the oversight to get rid of anything he didn't want you to see, so good luck). It's an unobtrusive gem waiting to be discovered where you can get access to original sources and the experts. Sure, if you go to the Reagan library in California you can walk through a three-quarter-scale Rose Garden, but even if you promise to be careful, you can't hold one of Ronald Reagan's neckties. Sometimes it's nice to be small.

JAINA LEWIS

When I went into librarianship, my friends and family said, "Aren't you a little loud for that?" But libraries need to have loud people. Growing up, I went to the library almost every day and nobody ever asked my name. I want to make that experience different for teens. I want them to feel that they're important—that what they read or watch or play or geek out to matters. I want them to know that there's a place where they can be themselves. Libraries don't grade you or judge you or care that you have the right Uggs or whatever. Just be yourself. We are here for you.

Teen Services Librarian

WESTPORT LIBRARY

SAM LEIF

Libraries can help stop a generational cycle of abuse, victimization, or anger. They can rehabilitate, help people grow, and change in life.

Correctional Facility Librarian

COLORADO DEPARTMENT OF CORRECTIONS

BONNIE SVITAVSKY

Libraries are places of community. We inspire people when we offer collections, programs, and readers' advisory, but we also allow others to share their ideas and we often bring people together in unexpected ways. One of my favorite recent programs was a cosplay panel we hosted last summer during which a teen asked how she could safely meet other cosplayers. Our speaker replied, "I think you've found them, right here," at our library.

Young Adult Librarian
PUYALLUP PUBLIC LIBRARY

JENNIFER ANDERS

School libraries are still the heartbeat of the school; the one place here every kind of kid in any clique can come together with other students to learn, collaborate, build, and create, in a nonjudgmental environment. And, we have books!

School Librarian
CORNER HIGH SCHOOL

DARLENE NICHOLS

There's tons of information on the Internet. Fifty percent is trying to sell you something. Another chunk is just plain wrong. Who can help you sort through it all quickly and effectively? A librarian. It's what we do, and we're good at it. We live to help out, so come and find out all the things libraries can help you to do.

Librarian for Diversity & Inclusion and Staff Development
UNIVERSITY OF MICHIGAN

JAYME R. SPENCER

As an academic librarian at an international institution, I feel strongly that we must build connections beyond our own doors. Today's technologies mean this is possible in a way it has never been before.

Director, Public Services
AMERICAN UNIVERSITY
IN CAIRO

JENNIFER SNOEK-BROWN

Libraries and librarians are even more relevent today, as Internet access and information resources threaten to overload and overwhelm us. Finding real information isn't like that old saying, "Finding a needle in a haystack." It's more like finding a needle in a stack of needles. It's becoming increasingly difficult to evaluate information found online. How do you know what is reliable? That's where librarians can help.

Faculty/OER Librarian
TACOMA COMMUNITY COLLEGE

YOUNG LEE

Growing up, libraries were a gateway to useful resources, to the local community, and to a world of possibilities for this first-generation American. To me, libraries are as American as baseball, hot dogs, and apple pie.

Reference and Electronic Resources Librarian
UNIVERSITY OF LA VERNE COLLEGE OF LAW LIBRARY

Jude Deveraux

When I was a child—and a precocious reader—my elementary school librarian handed me *The Borrowers*. Tiny people doing interesting things! I was in love. And I devoured biographies. I think the books of my childhood, with their cut-and-dried heroes, had a great influence on what I write today.

My favorite memories of libraries come from when I wrote historicals and traveled all over the United States and United Kingdom to research them. It was before the convenience of the Internet, and I couldn't have done it without the librarians. I flew from city to city, staying in hotels while I did intense research. I put everything on three-by-five cards that I wrestled onto a huge Rolodex machine that twirled around. I had boxes of photocopied papers, and I spent hours reading microfiche.

I have a passion for the old Carnegie library buildings, and I sought them out. A beautiful building filled with books—a dream come true! I spent hours in those gorgeous old libraries.

My personal library was enormous. At one time I had over six thousand research books, about half of them on costume history. I wanted to know what people wore from the skin out.

Through it all, the librarians were always there to help. When I said, "I'm trying to find out if they had button fastenings on clothes in England in 1283," not one librarian told me to go away. Instead their eyes lit up, and they found wonderful old books for me.

I so envied what librarians knew that after I'd had a few novels published, I decided to go back to school and get my PhD in library science. I took just three courses. They were so difficult that I ran back home. No more of that! Voiced and unvoiced *th*'s still haunt me. My respect for librarians is immense!

I think it's ridiculous that people are saying the publishing world is being killed by electronics. It's just a different form. I'm really curious about how the kids today are going to change publishing. They do nothing but read. Texts, Twitter, et cetera. They write more than they talk. How will that change the future? And what is coming next? When these kids reach sixty, how will their grandchildren communicate? Telepathically?

Based on my experience with librarians, they will more than cope. And for me, every time a librarian says, "I can help you with that," I get a warm, fuzzy feeling that reaches down into my bone marrow.

Jude Deveraux has written more than seventy novels set from 1283 to the present. Sixty-plus of them have found their way onto the New York Times *bestseller list.*

INGRID RUFFIN

Libraries aren't about books, the Internet, programs, or even the critical services that we provide. They are about the people we serve. Without people all the books, computers, and programs mean nothing. People should be at the center of everything we do and say. If you get caught up in metrics, surveys, and goals we can potentially miss what we are here for . . . people.

Student Success Librarian
UNIVERSITY OF TENNESSEE—
KNOXVILLE

BRIAN MAYER

Libraries embrace and explore so many mediums beyond those traditionally associated with the profession. We are about building communities and ideas. Libraries give you the skills and the tools to do anything.

Gaming & Library Technology Specialist

SCHOOL LIBRARY SYSTEM, THE GENESEE VALLEY EDUCATIONAL PARTNERSHIP

ROBIN KEAR

Librarianship is a calling. We are passionate about our corners of the profession. We contribute to the education of everyone. We must continue to fight for equality and privacy.

Liaison Librarian

UNIVERSITY OF PITTSBURGH

NICOLE POWELL "NEECHAN"

I was inspired to become a librarian because I am passionate about working with the public and overcoming obstacles regarding race, censorship, and social injustice.

Branch Supervisor/Librarian

SACRAMENTO PUBLIC LIBRARY

Amanda Palmer

When I was fifteen, I decided I just couldn't take it anymore.

I remember the moment: It was during algebra II (the very mention gives me hives), and I was sitting at a desk from which I was not supposed to move.

I didn't like or understand the teacher. I didn't like or understand the other students. And I didn't like or understand myself, but I wouldn't twig that until years later.

I put my books in my bag, stood up, walked out of the room and into the hall, and kept walking until I was off school property.

I felt so liberated. I WAS IN CONTROL. THEY COULDN'T TELL ME WHAT TO DO! I ACTUALLY HAD FREE WILL!

But then I was in a pickle. Because in the exhilarating delirium of Shawshank-style escape from Lexington High School, I hadn't given any thought to where I was going. Home was not an option. And Lexington had limited choices. There was the Denny's. There was the CVS. There was The Library. The LIBRARY! I didn't have to think twice. I already considered The Library a panacea, and the librarians were the stewards of a magical safe-zone. I didn't *know* any of the librarians, and I barely remember talking to any of them. I remember they were helpful. But that didn't matter; what I knew was that they weren't angry at me, they weren't trying to boss me around, and they were perfectly willing to let me sit there in peace, reading or writing fully uninterrupted and unjudged, for as long as I wanted. That made them GOLDEN. I was already in the habit of hanging out in the Library basement with my friends to do homework, and I used the Library card catalog every time I needed to write an essay. There were record albums to pore through. CDs. And the Xerox machine—which we learned how to cheat by leaving the copy key stuck halfway in so the counter wouldn't move. We made Xerox art of our various belongings. We were happy in The Library.

And since I used to think in large, sweeping dramatic generalizations (wait, used to?), so it was that I got the idea in my head that I would drop out of high school and educate myself at Cary Memorial Library in Lexington, Massachusetts. It made sense, right? I was motivated. I liked to read. All the knowledge that they were trying to force down my throat in school was technically THERE, IN THE

BOOKS. And I wouldn't have to negotiate any of the pain of high school! Why hadn't more people thought of this? I went to the CVS, bought a blank composition book, and then, after smoking a motivational clove cigarette (what else) in The Library's parking lot, I entered the back door of The Library, picked a desk, sharpened my pencils, and got to work.

It only lasted two hours, unfortunately. I got bored. I probably should have come up with a more interesting curriculum for myself (I gave myself the task of finding the largest dictionary possible and writing down definitions of interesting words in my new composition book), but honestly it just got a little lonely. If I could wind back the clock, everyone would have left high school and just joined me in The Library.

I just finished reading a wonderful book called *Last Child in the Woods*, about the importance of kids having untouched, natural open spaces to exist in. A place that doesn't run on the adult clock. A place where you are allowed to explore the world, and your feelings about the world, at your own pace.

There is something of that in The Library, which, in a pinch, is more than just a safe little place to escape; it's a house of infinite portals to other worlds, other ideas, other lives, other times. A forest of books, a woods of the heart. May libraries exist forever. Or teenagers like me will have to hang out at the CVS, and we don't want that.

Amanda Palmer rose to fame as the lead singer, pianist, and lyricist for the acclaimed band the Dresden Dolls, and performs as a solo artist as well as collaborating with artists including Jonathan Richman and her husband, author Neil Gaiman.

MARIAN MAYS

Libraries provide important services that target underrepresented communities. Without libraries, many individuals could not read, write, or use a computer. These basic services can change lives. I want people to realize that libraries are transforming every day. Libraries are pulling our communitites together and strengthening them. People don't know about so many of the services libraries provide.

Recent MSLIS Graduate
UNIVERSITY OF KENTUCKY

RACHEL ZILL

There are too few places left in this world that aim to challenge a system in which money trumps merit and encourages childlike imagination in the minds of all ages. The library is the only institution that allows us to truly be ourselves, openly creating, discovering, and changing the world.

Graduate Student
UNIVERSITY OF MISSOURI-COLUMBIA SCHOOL OF INFORMATION SCIENCE AND LEARNING TECHNOLOGY

SHERRY MACHONES

If my library shut down tomorrow, it would be a life or death situation. We are the only source in town for high-speed Internet. We are the only free cooling station in the summer. We are the only voting location big enough for the population. We are the only LGBT-safe zone in our rural, conservative town. Poverty is a huge issue. We are the only place for people to go to get food stamps and energy assistance. We are vital.

Library Director
NORTHERN WATERS LIBRARY SERVICE

HEELA NAGSHBAND

I was born in Afghanistan and at the time there were no public libraries. In fact, my mom worked at the library at the US embassy. Then the war started and we left, but libraries always played such a huge role in my life growing up. I can't help but think what a huge impact public libraries would make in countries like Afghanistan. A place where everyone, regardless of gender, ethnicity, religion, age, income, is equal and has the same free access to information, history, knowledge, and power just like I was able to get. That is what inspires me to be a librarian.

Reference Librarian
HENDERSON DISTRICT
PUBLIC LIBRARIES

KATHRYN DEISS

Connections. Curiosity. Exploration. Creativity. Discovery. Ideas. Questions. Inventions. Delight. Learning. Librarians offer this for free. They introduce us to the new and give us tools to bring clarity to the present, to discover the past, and to create the future. Librarians create uniquely open and free spaces in our communities. They are the intellectual and psychic daylight that illuminates the vast universe of knowledge and information. The world can count on librarians—in places rich or poor, urban or rural, central or remote—we will be there to open doors of all of human endeavor!

Content Strategist
ASSOCIATION OF COLLEGE
& RESEARCH LIBRARIES

SARA SUNSHINE HOLLOWAY

Libraries provide a community gathering place with resources, information, entertainment, and socializing for no commerical payoff. Our payoff is a healthy, literate society.

Teen Services Librarian

TACOMA PUBLIC LIBRARY

ED SPICER

Libraries have been, are now, and will continue to be the academic heart and soul of our communities.

Educator
NORTH WARD ELEMENTARY

MEERA GARUD

I was inspired to become a librarian because I believe information allows people to grow and improve their lives. Librarians help all people.

LIS Student
UNIVERSITY OF HAWAII
AT MANOA

KATHRYN BENSON

Librarians are human filters and curators of knowledge. They will alway be relevant if they do their job well.

Reference & Instruction Librarian
TULSA COMMUNITY COLLEGE

The American Girl

Briony Zlomke Beckstrom
and the Franklin Public Library

FRANKLIN, WISCONSIN

As an eight-year-old Briony Zlomke Beckstrom was obsessed with American Girl dolls, a set of extremely elaborate eighteen-inch figures produced by Pleasant Company since the mid-1980s. The line includes accessories, clothes, and furniture. Each doll has a name and a story, which is told in an accompanying book. Every doll is rooted in a particular time and place—some historical, like Rebecca Rubin, a nine-year-old Jewish girl living in New York City in 1910, before World War I, and Melody Ellison, a nine-year-old African American girl growing up in Detroit during the civil rights movement in 1964. Others are contemporary, like 2013's Saige Copeland whose backstory plants her in Albuquerque, New Mexico, where she loves painting and horseback riding, or 2016's Lea Clark, a wildlife enthusiast who aspires to be a photographer. (One of her accessories is a blue-and-white camera.) When Briony was a child, American Girl dolls retailed for seventy-five dollars, which was far beyond the means of her family, with a military father and a stay-at-home mom. But that didn't keep Briony from dreaming, or obsessing. She would pore over the catalogs and circle the things she wanted the most, playing with pictures of dolls she couldn't afford to own.

Today Briony is a youth services librarian at the Franklin Public Library in Franklin, Wisconsin, a small suburb of Milwaukee, and she remembers her obsession vividly and enthusiastically.

"There was Addy, who escaped from slavery and was living up north. And there was Molly, growing up in the 1940s, whose father was fighting the war, so

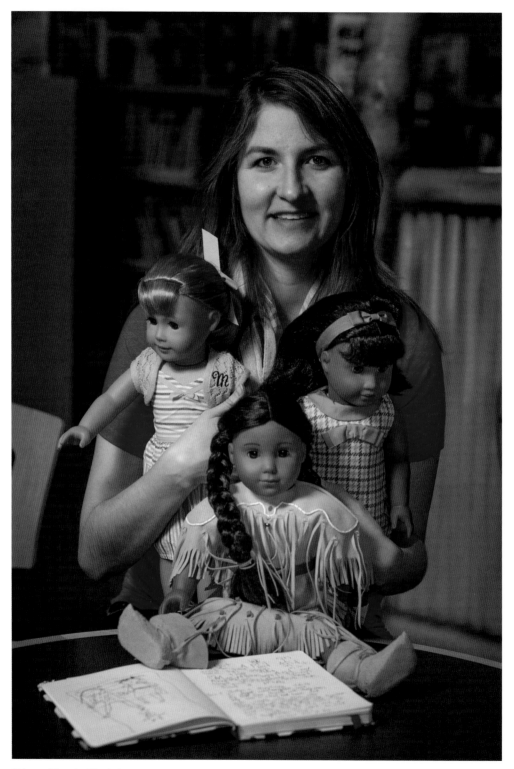

Briony Zlomke Beckstrom

she would help sell war bonds. And there was Samantha, who was a Victorian orphan being raised by her grandmother whose uncle's girlfriend was a suffragist, so there were all these stories . . ." Stories that churned Briony's imagination even as she grew older, leaving a nagging sensation of something unfulfilled. At twenty-eight her parents finally bought her a doll (they retail for $115 now); it sits on her bookcase. But it's not the same as having it at age eight. As a librarian Briony wondered if there was something she could do to keep children from having to wait twenty years to get something they wanted so desperately, a feeling that she palpably understood.

Briony approached the director at the Franklin Public Library and said, very quietly, "WE SHOULD DO AN AMERICAN GIRL DOLL LENDING PROGRAM!" There were those who met this proposal with skepticism. "This is an affluent neighborhood," some said. "If people want dolls, they buy dolls." Briony persisted, reminding friends, neighbors, co-workers, and board members that the library served multiple demographics. "We *really* should get a doll to start loaning out," she said. *Just one doll? One?* Briony's director appreciated how relentless this librarian was. She looked at the library funds and decided to take a chance. "Well," she said, "we have a budget. Why not buy all of them?"

Briony got all of the dolls and announced that the library was having an American Girl tea party where there would be cookies and lemonade, crafts, and an improvised theatrical performance; children could come and play. Briony had two secrets, one of which was that the dolls would be available for loan after the tea party. The other, possibly more outrageous, secret: They were giving one doll away. Her library director thought it would be a good way to launch the program. Along the shores of Lake Michigan in eastern Wisconsin, it was about to start raining joy.

The party was packed; between parents and children there were more than sixty attendees. There was tea. The girls made Victorian calling cards, and Briony put them in a jar. She shook up the jar and announced to the shocked tables that one child would get to keep Samantha Parkington, the Victorian orphan who lives with her grandparents, loves to paint, and plays piano. Time slowed down. Mouths opened. "It felt like everybody had stopped breathing," Briony said, "not just the girls, but their parents, too." She drew a card and announced a winner. Then, she turned to all the disappointed faces and announced the library's new program: "If you didn't win Samantha, we have all these dolls . . . and you can take one home for

seven days, and you can bring it back and then *get another doll.*" Jaws hit the floor. *Take the dolls home?*

Briony carefully packaged all of the American Girls into individual pink carrying cases, with their book and a journal so that children could write down their experiences; she wanted to know what sorts of adventures they were going to be having. She entered all their accessories into the library catalog, photographing each piece, each shoe, each barrette, so they'd know what came in and what went out. She got each of the dolls a call number and barcode. She put them on the shelf, posted a note to Facebook, and said "*Please let these dolls go out* . . . this would be a *lot* of money for them not to go out. I don't know how I'm going to tell the board of directors that we bought eight dolls at $115 apiece and they're just sitting there."

Journal excerpt from the American Girl doll program.

Briony waited at the circulation counter and watched. Time passed. A girl came and took a doll, and another girl came and took a doll, and then . . . it exploded.

Dolls were checked out as fast as they were returned, parents and grandparents came to the library scouring the shelves for anything, people waited in the lobby like deer hunters. Briony decided not to allow holds on dolls because Franklin's hold policy gave people five days to pick up an item, which was five days, she decided, that a doll wasn't with a child and that's where it needed to be. Sometimes when patrons walk in carrying a distinctive pink case they are immediately followed by out-of-breath parents bursting through the door behind them because they'd seen from across the street what looked like a doll being returned.

In the two years since it started, the troupe has grown from seven to eleven, and the dolls have remained the second most popular collection in the entire library, surpassed only by the Express DVDs. Briony thinks she could eclipse even those if she changed the take-home time from seven days to three, but because she still remembers being the little girl circling pictures in catalogs, wanting something so desperately, she can't imagine doing that. Once a month Briony schedules some activity, "not necessarily tea parties," she says, "but rather an hour-and-a-half program where kids learn a little about the doll I picked, make some crafts or participate in some activities, and enjoy some food based on the events. I still lead them. I do have helpers, but I mostly plan out the time line and lead it. I have done dolls from today's age back to the historical dolls. I've done photography, poodle skirts, voting, pet rocks, and so much more with the kids." And it's not just the girls, but their parents and guardians, too, some of them perhaps, like Briony, remembering a time when this would have meant everything to them. Participation at the tea parties hovers around fifty, with some at capacity (sixty); it never dips below forty.

The personal satisfaction of starting something so popular is magnified when she sees other librarians who've started similar programs at their own libraries. She has a Web page of advice for other libraries: Start slow with a few dolls or you'll be checking out and returning dolls all day long, and think twice about getting dolls with curls, or you'll spend a lot of time fixing their hair.

Sometimes Briony wonders, "*Did I create a monster?* But then I see these girls and how happy they are."

SHELBY E. HARKEN

I'm a cataloger. Everything is
rules but I'm willing to bend
rules when users need help.

Head of Technical Services
CHESTER FRITZ LIBRARY,
UNIVERSITY OF
NORTH DAKOTA

KATHRYN RICHERT

Libraries are the mecca for early literacy. Story times and books galore! My goal in life is to find the perfect book for any child who asks.

Assistant Head of Youth Services
BLOOMINGDALE
PUBLIC LIBRARY

HEATHER MYERS

Libraries are the great equalizers. In a library, everyone is on the same footing and we all have the potential for greatness.

Circulation Coordinator
FRANKLIN COLLEGE

MARIO VEYNA-REYES

Libraries are becoming social centers where people can come for recreation or to learn.

Children Services Librarian
LAS VEGAS–CLARK COUNTY
LIBRARY DISCTRICT

TREVOR CALVERT

Libraries are a vital cultural resource, as democratic societies require an informed population. Libraries provide not only information but countless other tools which serve to strengthen, inspire, organize, educate, and entertain communities.

Librarian

MARIN ACADEMY HIGH SCHOOL LIBRARY

TIFFANY GARCIA

There would be complete anarchy if libraries suddenly vanished. The information, resources, and programs we offer are unique and free. I love my job—I love reading and I love people. Connecting people with words is one of my favorite things.

Community Library Supervisor

MID-COLUMBIA LIBRARIES

Nancy Pearl

When I was growing up, my most fervent wish was for a happy family, one unscarred by anger and anxiety. But close on the heels of that wish was this one: That I could live inside a library. Although any library, anywhere at all, would probably have been just fine, I had a specific one in mind. Formally its name was Parkman Branch Library, part of the Detroit Public Library System, although I just thought of it as "my library." I had no idea how to make my family happy, but moving into "my library," my primary escape and salvation, the place where I felt most untroubled and cared about, most at home, seemed like a plan.

One problem that I saw early on was that the Parkman Branch had no public restrooms. That would definitely complicate things. But I figured that at night, when the library was closed, I could use the bathrooms the librarians used, and during the day I could go to a nearby gas station to pee. I made up elaborate scenarios that involved sneaking a sleeping bag into the library and hiding under a table to remain undetected when the library closed. (I was a child who devoured novels about kids encountering magic in their lives—*The Lion, the Witch and the Wardrobe*; *Half Magic*; *The Thirteenth Is Magic*—and I managed to half convince myself that when you crawled under one particular table in the children's room you became invisible.)

In the meantime, I spent as many of my waking hours as I could at my library. I would ride my bike (my trusty steed, Charger) the two or so miles there nearly every day after school. On Saturdays I would be at the library when it opened at nine o'clock and I'd still be there when it got ready to close at five thirty. I'd pack a lunch at home and eat it outside, under one of the many trees that lined the strip running down the middle of Oakman Boulevard, the street on which the library was located. My library was closed on Sundays, and, perhaps for that reason, Sunday remains to this day my least favorite day of the week.

I always thought that my library was one of the many libraries given to communities across the country by the robber baron Andrew Carnegie. It certainly shared many of the distinctive characteristics of a typical Carnegie library: You walked up a set of stairs to get to the front door (Carnegie evidently liked the metaphor of the library patron "ascending to knowledge"), with a center entrance that faced the cir-

culation desk, and then you turned to the right to get to the children's books and to the left to get to the adult collection. But writing about my library in the introduction to *Book Lust: Recommended Reading for Every Mood, Moment, and Reason*, I said as much, and one of the book's readers wrote me to point out that Parkman Library was built much later than the other Carnegie libraries around the country, so it probably wasn't one of the libraries actually funded by Carnegie himself.

Officially Carnegie or not, my library was a place of discovery, of wonder, of excitement and joy, as well as a place of friendship and acceptance. I haven't been back to my library in many years, but I could still draw you the floor plan of the children's room. I could show you the exact spot where I was sitting when I picked up (from the bottom shelf) a copy of Robert Heinlein's *Space Cadet* and started reading it, thus beginning my lifelong affection for science fiction. I could easily lead you to where the children's fiction was, and even point out where Eleanor Estes's *The Moffats* was shelved. And I can still envision in vivid detail what was for many years my favorite section of my library: the horse and dog stories. I scour used-book stores and Little Free Libraries for copies of *Pennies for a Pony* or *The Dog Next Door*, two of my all-time favorites, so I can revisit them. I could walk you over to the "Too Good to Miss" display, filled with the books that Miss Whitehead, the best librarian I've ever known, urged upon me, offering them to me as precious gifts: *The Hobbit*, *The Wind in the Willows*, *Mary Poppins*, *Greyfriars Bobby* . . . I could even show you where the magic table was, if you promised not to reveal its whereabouts to anyone else.

I still have the happiest memories of the hours and hours I spent in my childhood library. I think it was primarily because of Miss Whitehead that I spent the early part of my career as a children's librarian, wanting to do for other children what she had done for me—giving me the invaluable gift of the joy of reading. And all of my career in the public libraries where I've worked has focused on encouraging a love for reading, and helping people find good books to read. So, while I've never actually lived in a library, the homes my family has lived in have always been filled with books, and always will be.

Nancy Pearl is a librarian and lifelong reader. She regularly comments on books on National Public Radio's Morning Edition. *Among her many awards and honors are the 2011 Librarian of the Year Award from* Library Journal; *the 2011 Lifetime Achievement Award from the Pacific Northwest Booksellers Association; the 2010 Margaret E. Monroe Award from the Reference and Users Services Association of the American Library Association; and the 2004 Women's National Book Association Award, given to "a living American woman who . . . has done meritorious work in the world of books beyond the duties or responsibilities of her profession or occupation."*

CHRISSY KLENKE

Libraries are in a very exciting time. Things, space, and collection materials are expanding, opening up, and becoming more diverse. Libraries are in a renaissance, and I am so proud to be a librarian and a part of all this.

Earth Sciences & Map Librarian
DELAMARE SCIENCE &
ENGINEERING LIBRARY —
UNIVERSITY OF NEVADA–RENO

MEGAN DAZEY

I was inspired to become a librarian by a family friend who was a librarian. She always encouraged me to love finding information and helping people. She died from breast cancer a few years ago. Now I feel the need to mentor people wanting to become librarians in her place.

Library Services Manager
PUYALLUP PUBLIC LIBRARY

ARIEL SLAYTON

Being a librarian gives me the opportunity to create change that I want to see in the world. I have given a woman the tools to start a search for her lost sister, helped an elderly man with his computer skills, and found the next book in a series for an excited teenager. All of these are equally important.

Branch Manager
SHREVE MEMORIAL LIBRARY

DALE McNEILL

Libraries are important because in a sea of information, libraries contain and curate information and culture; they connect people with those resources; and they provide a place . . . I think the place is as important as the information and culture.

Assistant Director for Public Service
SAN ANTONIO PUBLIC LIBRARY

ANNA E. GENTRY

Books change lives. They expose individuals to ideas that can save the world of one or the world of many. Librarians are guides to the many pathways books offer. Information is my lifeline. I do what I do to share this lifeline with those who need it most.

Network Librarian
FIRSTLINE SCHOOLS

RACHEL E. WINSTON

What would we do without our elders? Grandparents, parents, aunts, uncles? They're the libraries and archives of our lives and society. Librarians and archives, like elders, reaffirm our sense of being, our purpose, and help inform who we are and how we interact within society. Who would we be to not take pride in them and take the time to make them as wonderful as possible?

MSIS Candidate, VF Austin (May 2015)

VF AUSTIN INFORMATION SCHOOL

JENAY SOLOMON

Libraries and librarians are the connection to all people, advocating for the right to information in all the right places, please support our library professionals.

Student — MLS — Emporia State

SCHOOL OF LIBRARY AND INFORMATION MANAGEMENT

SARAH BENTLEY

The greatest challenge libraries are facing today is learning to do more with less.

Team Leader Access Services
RICE UNIVERSITY,
HOUSTON, TX

EMILY BULLOUGH

We're here to help people. I work in a university library, and I'm there to help our students, first to feel welcome, and then to connect them with the information they need to succeed in their classes.

Reference and Instruction Librarian
UTAH VALLEY UNIVERSITY
LIBRARY

EVA VOLIN

When you have the opportunity to share in the joy a child feels when she or he first discovers what a powerful thing a story can be—especially when reading hasn't been a positive experience before—why would you do anything else?

Supervising Children's Librarian
ALAMEDA FREE LIBRARY

STEVEN YATES

Libraries are one of society's best protectors of freedom, equality, and access for all. Librarians use their passion to continue reinventing libraries into vibrant community spaces—and our drive to serve is tenacious!

Instructor
UNIVERSITY OF
ALABAMA SLIS

Bringing the Library to You

Bretagne Byrd and the Lewis & Clark Bookmobile

MONTANA

Just out of college, Bretagne Byrd was hiking the Appalachian Trail. With no cell phone and no laptop, her only communication with the outside world was achieved by finding computer terminals in libraries in the towns she stopped in. "It's the only way my parents knew I was okay," she says.

Somewhere out there, between the trees and the towns, between the bears and the deer, she had an epiphany and realized that she wanted to help provide these services to people who didn't have them as part of their daily lives. "While I was hiking," she says, "libraries were my shelter from inclement weather; they were my connection to the world. They're in every single town—libraries are one of the last public spaces. During that time in my life I was very transient, and I wanted to stand up for something that was valuable to every community."

Bretagne moved from Virginia to Indiana to get a degree in library sciences and then to Helena, Montana, where she started driving a library. Her bookmobile began from the ground up, in a job created specifically for her that started with finding the right truck.

"When you look at purchasing a bookmobile," she says, "you want to look at how far it's going to go. When you're in rural Montana you're looking for something that's hearty. We have seventy-mile-per-hour speed limits, we do go through a couple passes, and some of the smaller communities are hard to get to in rough weather. A lot of my stops are in dirt parking lots, on dirt roads, and when it's raining it's very muddy so we needed something that could handle those roads. The vehicle we chose is a Freightliner. It's thirty-two feet long. It's a very large truck."

BRETAGNE BYRD

As one of the last available places of free public space in a community, libraries are a vital source of collaboration, education, and access to information—even a sanctuary from inclement weather.

Bookmobile Librarian

LEWIS AND CLARK LIBRARY

Bretagne uses the bookmobile to bring library services to rural towns that can't afford libraries of their own—and by *library services* she means not just books, but things like Internet access, too. Her truck provides free WiFi, so people who don't have it at home will come out to her library to use their laptops, check their mail, and order things from Amazon. And sometimes people are just happy to see a new face; a personal connection to the outside world is an important service, too. "People come out to just talk to me," she says. "There's not a lot of social interaction in some of the rural areas so it's very exciting to see someone every two weeks and be able to talk about what they're reading, their entertainment needs." Montana has been physically isolated ever since human beings first migrated there. It's the place where in the 1870s "Stagecoach" Mary Fields delivered the mail while carrying a rifle, dodging wolves, and dragging the mail over snowdrifts when they got too deep for the horses; today mail is still sometimes delivered by snowmobile. But today's world moves faster, and experiencing the world without an Internet connection is to be at a disadvantage next to your peers. Poverty and sheer remoteness are two things that hamper some people's ability to get an Internet connection of their own. In addition, some places just don't have Internet connections or cell phone coverage, and it's not uncommon that people will have to wait two weeks between email exchanges and Facebook updates.

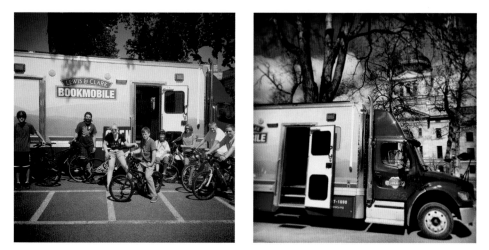

You can see the bookmobile's schedule or follow it on Twitter from the Lewis & Clark Library's Web page.

Bretagne's area is large. Lewis and Clark County encompasses the city of Helena with its twenty-eight thousand residents in sixteen square miles, and the surrounding countryside with a population of forty thousand spread over nearly four thousand square miles, much of it mountains, prairie, and forest.[3] Within those four thousand square miles the bookmobile makes stops, ranging between one and two hours, in towns where sometimes a gas station parking lot is the closest thing there is to community space. It visits assisted living facilities, where sometimes Bretagne will deliver books inside because of patrons' mobility issues. It stops at schools that don't have their own libraries, some with as few as thirteen students, and schools that share a librarian. Sometimes the school-shared librarian catches a ride with the bookmobile between towns; in those schools the libraries are shelves, not rooms. At most stops people are waiting, usually to get on the computer. Access is the most important thing the bookmobile provides. Some of the bookmobile's remote patrons only venture into the nearest town four times a year. Without the library coming to them, they would largely be without current reading material and a connection to the outside world.

The bookmobile also has around three thousand items that can be checked out—not just books but also DVDs and even an extensive puppet collection. Though a big part of Bretagne's job is figuring out what's going to be in demand and stocking the shelves accordingly, the bookmobile can bring patrons books from any of the four branch libraries.

There are also two public access laptops and a child-oriented tablet that young patrons can use to play learning games. Using the Internet to help people get access to resources is another important part of the bookmobile's job. The bookmobile offers classes on how to check out items online and use eReaders. Even owning an electronic device, many patrons still have to meet the bookmobile to download books because of the lack of an Internet connection.

The rural nature of the job comes with some advantages: a den of foxes out near Augusta where the babies sometimes greet the bookmobile by poking their heads out; the ubiquitous deer, elk, and bighorn sheep. Bretagne has stashed a pair of binoculars in the library's cab to watch the wildlife. Someday she's hoping to see a bear.

[3] This is roughly the same number of people as is found in Passaic City, New Jersey, all of whom live within 3.2 square miles, with nobody more than 2 miles from a branch.

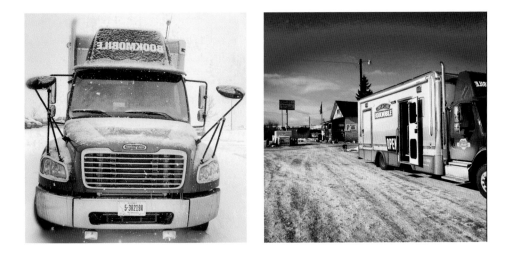

The landscape presents its own challenges. While stopped at a Hutterite colony in the winter snow began to fall at an alarming rate, and Bretagne realized that if she didn't leave she was going to be snowed in. But it was too late. A fierce wind had already drifted snow well above the truck's tires. She and her assistant had started trying to dig their way out when community members noticed and showed up with a tractor to pull the library onto the road.

Building relationships like this and providing tailored services to communities are what libraries around the country are doing, and not enough people know about it. "The most important challenge libraries are facing is the lack of awareness of what we do," Bretagne says. "People don't realize how creative we are and everything that we have to offer. A lot of people, especially with my generation, are unaware. Once people know that we're there, they get involved and they get really excited."

And that's the battle.

SARAH HOUGHTON

Librarians democratize information and expertise.
We protect your privacy and your right to learn.
Libraries are the one institution that equalizes the
intellectual playing field. I can think of no other pro-
fession I'd want to dedicate my life to.

Director
SAN RAFAEL PUBLIC LIBRARY

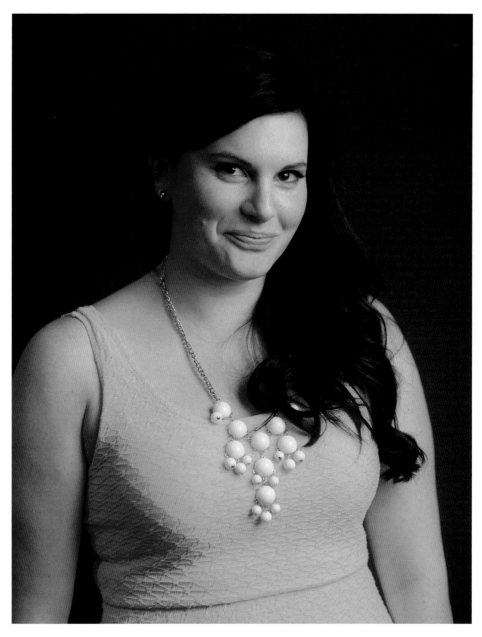

ELISSA BURNLEY

The greatest challenge facing libraries today is relevancy. We struggle to remain current in a new, ever-changing world. This is a welcome challenge, though, as we have been inspired to move further into our communities, entwining ourselves deeper with the people who need us.

Community Engagement Specialist

MID-COLUMBIA LIBRARIES

CHRISTINA BELL

When I told him I wanted to become a librarian, my dad envisioned me doing story time with kids. I'm an academic librarian, and I never do that. Libraries and librarians are just as diverse as our communities. We are committed to knowledge in all its forms, and work to empower people to love learning and discovery as much as we do.

Humanities Librarian
BATES COLLEGE

MEGAN McFARLANE

Libraries open up a world of opportunities for all people regardless of socio-economic circumstance, age, race, sexual orientation, religion, or education. They provide a service that no other institute does and they do it for free! Libraries and librarians give back to society, humanity, and culture and I am unimaginably proud to be counted among their number.

Campaign for America's Libraries /
Library Student
AMERICAN LIBRARY ASSOCIATION

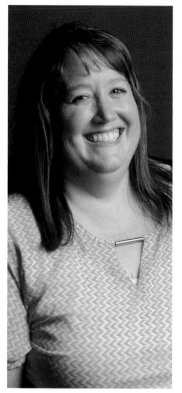

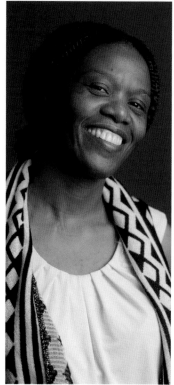

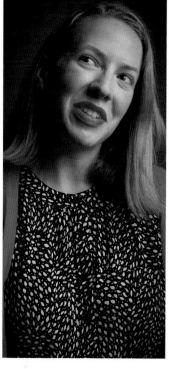

KATHY BUNDY

I was drawn to being a librarian through my love of teaching students, the love of reading, and the notion that all answers can be found in books. To paraphrase Neil Gaiman: "Google can give you lots of answers, a librarian will give you the correct one."

Elementary School Librarian

SALT LAKE CITY
SCHOOL DISTRICT

MAUD MUNDAVA

We live in a digital environment, but librarians will always remain relevant. I am pround to be a librarian because I am changing lives every day.

Curriculum Materials Librarian

ROBERT W. WOODRUFF
LIBRARY, ATLANTA
UNIVERSITY CENTER

CHARISSA POWELL

We're here to help. I work with first-year college students and this is the main message I always want to get across: If you have a question, ask!

Undergraduate Experience Librarian

KANSAS STATE UNIVERISTY
LIBRARIES

Paula Poundstone

When my kids were little we went to the library a lot. They joined in the summer reading program every year. The library gave them a chart with pictures of clocks on it so they could keep track of their reading hours. They got a sticker for each clock they filled in, and when the whole chart was filled in they got a T-shirt. It was a fun motivation. We chose books slowly, sitting on the floor among the shelves in the children's section. We looked at the pictures and the cover. If those passed muster, we took them over to a table, sat down, and tried out the author's voice. If the book made it over that hurdle, we checked it out. I would choose books that I wanted to read to them. Mostly the ones that made a deep impression on me when I was a kid—*Ramona the Pest*, *The Boxcar Children*, *Pippi Longstocking*. Occasionally I found something that just cried out to be read to them, like the book about the history of plumbing and bathroom practices, and we would just sit right in a beanbag chair and devour the whole thing right then and there.

At one point Santa Monica, where we live, decided to rebuild the main library. All of the books and resources got temporarily housed in the smaller branch libraries. We found where most of the children's books had migrated and frequented that library for a while. It was overstuffed with new guests. On one visit to that library, my daughter Toshia and I sat at a table auditioning a couple of books to see if they made the cut to be checked out and taken home, and there at a table beside us sat two women. We couldn't help overhearing them. One woman was teaching the other to read. We tried not to stare and left as soon as we could, to give them a bit more privacy.

I gathered the other kids and went to the car. I had goose bumps. "That volunteer," I told my three kids, "will never need to wonder if her efforts are actually making a difference in the world, because what she is doing will undoubtedly have a ripple effect. That courageous woman who reached out because she needed help learning to read will soon be able to read to her own kids, which will enable them to read to theirs." The Santa Monica library provided that volunteer program to teach adult community members to read.

I tear up even now as I tell you about it. For an adult who had never pinched in her fingers a bunch of pages that she had already read to compare it with how

many she had to go or look forward to the next time she could sit down and read, to now be able to return to the library and find the author who speaks to them, is one of the greatest community services we can give to one another.

Paula Poundstone is a stand-up comedian, author, actress, interviewer, and commentator. She is a frequent panelist on National Public Radio's weekly news quiz show Wait Wait . . . Don't Tell Me!

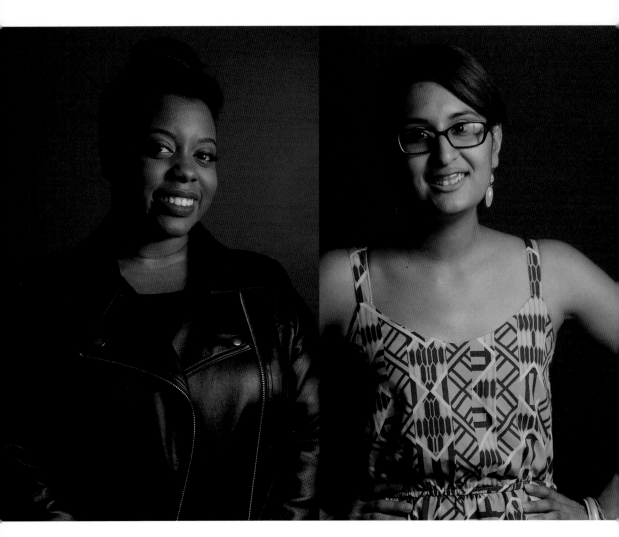

MEGAN THREATS

As a librarian for an AIDS Service Organization, I am able to deliver services and design and conduct projects that improve access to HIV/AIDS related health information for patients, the affected community, and their caregivers. Libraries are the epicenter for access to information, and librarians have the unique opportunity to help users build digital and information literacy skills that are transferable and applicable in everyday life.

Librarian

AIDS LIBRARY OF PHILADELPHIA FIGHT

KARINA REYNA

If all the libraries in the community shut down, the community woud lose more than just the ability to distribute library materials. Librarians are a hub of resources for communities and provide opportunities for people to help themselves and connect with other members of the community.

MLS Student / Knowledge River Graduate Assistant

UNIVERSITY OF ARIZONA KNOWLEDGE RIVER

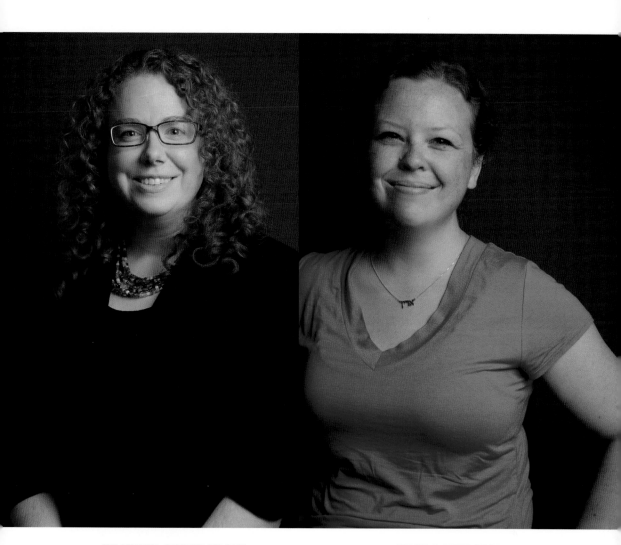

HEATHER GREER KLEIN

Libraries frequently pool their resources to provide even more value and equity of access to the people of their region or state. Libraries can do so much on their own, but when we band together as partners and consortia, look out! We make incredible things happen when we recognize common needs and develop our solutions together. It is just one more way libraries make their limited resources go farther.

Services Coordinator

DURASPACE

ERIN BOYINGTON

Reading and learning can open the mind, but only as far as the reader or learner is willing to be opened. I can't make anyone embrace change—I simply continue to provide the opportunities. It's all up to you. It's what you choose to spend your time on, and how much you choose to challenge yourself. Nowhere is this more obvious than in a prison.

Library Technician II

STERLING CORRECTIONAL FACILITY,
COLORADO DEPT. OF CORRECTIONS

TOPHER LAWTON

Everything comes down to information. Librarians know how to use it, find it, and share it with the world, and they're ready to help everyone else do the same.

Science Librarian
OLD DOMINION UNIVERSITY

MADELEINE ILDEFONSO

Libraries and the people who both work in them and use them have the power to transform communities. Libraries and librarians humanize the experiences that change lives. We advocate for the individual for a greater collective achievement. In urban communities, libraries are where neighbors meet and discover that they share the same interests and values.

Senior Librarian/Branch Manager
LOS ANGELES PUBLIC LIBRARY

DEV SINGER

When I was in high school, the library was where I learned that there were other people like me. The complexities that come from being Jewish and being a lesbian were something that other people, older and wiser, grappled with. The library is a place where people like me, and anyone else who doesn't fit in, can learn that we are not alone.

Assistant Librarian
ANDOVER NEWTON
THEOLOGICAL SCHOOL

KATHARINE KAN

Libraries provide research help that goes way beyond Google and Bing, and librarians are the greatest facilitators to help people find the most relevant information they need. They also carry a much wider range of reading material, in books, magazines, comics, and graphic novels, as well as digital resources.

Librarian
ST. JOHN
CATHOLIC SCHOOL

HEATHER MOOREFIELD-LANG

When I was a kid the library was the only place where I could take as much as I wanted, from books to information. That's not true of anyplace else. For me, libraries will always be the place to get anything and everything.

Assistant Professor

UNIVERSITY OF
SOUTH CAROLINA

ALEXIS SKIDMORE

Libraries are more than books. We are even more than story times, digital materials, DVDs, galleries, senior centers, job services, and Internet access. We are as vital and vibrant as our communities. Come see!

*Youth and Teen Services
Library Assistant*

SCOTTSDALE
PUBLIC LIBRARY

ANNA BRANNIN

Our purpose is to serve our communities however best we can. We're an ever-evolving resource that's been about more than just books for a long time. Your library is a place to learn and grow and meet and celebrate.

Librarian

SAINT STANISLAUS
COLLEGE

RACHEL ALTOBELLI

School librarians and libraries have the power and potential to transform the lives and educational experiences of our students. Especially today, with technology changing rapidly around us, we must prepare our students to be innovative thinkers and creators. We don't know what their workplace tech will be, but we do know that strong teacher-librarians can help them develop the skills to navigate it.

Director, Library Services and Instructional Materials
ALBUQUERQUE PUBLIC SCHOOLS

LOIS HAIGHT

After giving a book talk to my class of fourth graders, one of my reluctant readers eagerly put the book on hold. A few weeks later, he came up and told me that he loved the book and was almost finished. That is why libraries are important: creating safe, creative, and fun learning environments for children, no matter their ethnicity, gender, sexuality, ability/disability, and so on.

Future Teacher–Librarian

RECENT MLIS GRAD AT
THE UNIVERSITY OF
WASHINGTON

STEVEN SMIDL

Technology has changed the game of information literacy. There are alternative methods to reading a book or finding articles and primary resources. As technology continues to advance through new initiatives, librarians have a duty to keep current and relevant. Personally, I embrace any emerging technologies because these can be teachable moments in which working with alternative resources can encourage reluctant patrons to ultilize the library in the future.

Librarian

GRANT COMMUNITY HIGH
SCHOOL LIBRARY

NAPHTALI FARIS

The important service that a children's librarian can provide is to create an open, welcoming space for children and teens. It's not always about reading. It's showing them a safe place in the world where they can discover their own truth. So much of a child's world is dictated to them. I love creating a space where they make the decisions. They become the agents of their own lives. It's so empowering.

Early Literacy Manager

MID-CONTINENT
PUBLIC LIBRARY

Sara Farizan

My love of the library began as a kid when, at the age of about five, I checked out *Piggybook* by Anthony Browne at least ninety times. And then *Commander Toad in Space*, all the Roald Dahl books, all the John Bellairs books, anything by Allen Say . . . I was a very active reader to say the least.

Until I went through that horrible thing called puberty and realized I liked girls and didn't want to. I thank the library for allowing me to furtively check out and read books that helped speak to my experience and made me feel less alone. I thank the library for being a place of refuge when I didn't really know what I was feeling, but found authors that had the words to help me. I thank the library for not judging me even when I judged myself so harshly. I thank the library for allowing me to learn about myself with dignity and in the privacy of a safe space.

And then another weird, crazy thing happened. I grew up. Gross.

But I decided I wanted to write for teenagers like me. So I went back to the library again. I read lots of YA titles by authors far better than me. I went to the library to write and have a type of office, even when I was unemployed/underemployed and felt like a loser. I went to the library to check out foreign films, documentaries, and articles, and just to feel like I was tethered to a place where my love for books all began.

I went to the library to stare at authors' names on the shelves and hoped one day I could be on that shelf. That a book I wrote could one day help someone like me.

If You Could Be Mine is my first novel and much of it was written in two respective libraries, both of which I hope stay open for a very, very long time. Because I have a lot more I want to write and I need a space that makes me feel like I can.

Also, please be sure to be friendly and courteous to your librarians. They love books, too.

Sara Farizan is the author of the bestselling novels If You Could Be Mine *and* Tell Me Again How a Crush Should Feel.

SARAH JANE LEVIN

Libraries are vital to the community not only because they provide free access to informa-
tion, but also because they provide the tools for people to learn how to navigate the ever
changing and new digital landscape.

Librarian

URBAN SCHOOL OF SAN FRANCISCO

MAJED KHADER

Libraries are very much like oysters; common, abundant, and seemingly ordinary. That is, until you find the endless beauty held within.

Director of the Morrow Library
MARSHALL UNIVERSITY

A Public Space

Tina Ely and the Greybull Public Library

WYOMING

"Is there anything else you'd like to see here in Wyoming?" my wife asks after we've settled into the Historic Hotel Greybull.

"Devils Tower," I respond. As a child I was obsessed with *Close Encounters of the Third Kind*.

"It's two hundred and sixty miles to Devils Tower," she says. "I'm not sitting in a car for ten hours so you can take a picture from the parking lot."

Very few things in Wyoming are near anything else in Wyoming. To get to Greybull from most places in America you have to go someplace else to start, usually Salt Lake City, Chicago, or Denver, and from there take a connecting flight to Cody. From there most of the people on your flight will head west for Yellowstone, but you'll drive east for forty miles toward the Bighorn National Forest. The landscape is vast, dotted with mule deer, antelope, moose, mountain lions, and black bears. Some dots are more common than others; I never saw a bear or a mountain lion, but a moose did wander past us in uncomfortably close proximity while we were minding our own business in a field. It was a difficult place to settle and remains one of the least densely populated states in the Union (only Alaska has fewer people per square mile).

The Greybull Public Library began in 1907 as an extension of the Fortnightly Club. The club's original purpose was "the study of literature" and its motto: "In essentials, unity. In non-essentials, liberty. In all things, charity."

Six years after the formation of the club, they began a library in Miss Carson's millinery store with seventy-six donated books. Lizabeth Wiley, the first woman

mayor of Greybull, also ran the town bookstore. She's quoted as saying, "I have not only a Library Bee in my bonnet—but a whole hive of them." I've never heard a phrase more deserving of being on a hat.

The bookstore and the library existed in a shed about four feet wide between two buildings. In 1919 it moved to the Alamo Hotel. In a quest to cater to all the town's needs, this hotel not only allowed patrons to check out books, but also contained a speakeasy serving illegal liquor.

But the library needed a permanent, dedicated space. In what may seem an improbable matchup, in the late 1960s a group of about forty local rock collectors were looking for a place to share their finds with the public. They'd spent their free time driving out into the prairie looking for rocks, fossils, and Native American artifacts. In 1968 resident Ely Riley donated a patch of land, and construction began on the Greybull Museum and Public Library. The space fulfilled a multitude of functions, serving not simply a home for books and a place to display local history, but also a very popular public meeting room. The library settled in and in 1988 issued cards for the first time. Today a Greybull library card can be used to withdraw books from any library in the state.

Left to right: Mrs. Wyant, Mrs. Inez Alderdice, Mrs. Johnson, Mrs. Fenton, Mrs. Herron, Mrs. W. W. Shaver, Mrs. Husted, Mrs. Merriot, Mrs. Engle, Mrs. Connelly, Mrs. Z. U. Knode, Mrs. Andy Hurst, Mrs. John White. Boys: Gerald Williams and (first name unknown) Merriot.

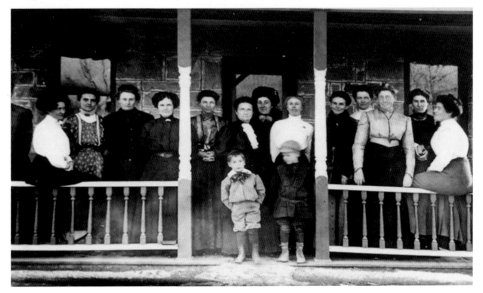

The people of Greybull use their library for many of the things that draw people to every other public library in the country. The computers are very popular for people looking for jobs, filling out IRS forms, printing documents, or just checking their email. High-speed Internet is still rare outside of town, where miles may separate neighbors; cell phone coverage is spotty and public WiFi nonexistent. There's often a waiting list to get on one of the four terminals. There's a book club that starts up in September and continues until the summer, when programs for children begin. Over three months the children of Greybull will read five hundred books while waiting for school to start up again. Also in the summer is the very popular Lego Friday when kids, and often as many adults, dive into tubs of blocks and hide their creations on the bookshelves. There are outreaches with two day cares; librarians bring books and often stay to read a story. Once a week there's a

Inside the Greybull Public Library.

The Greybull Public Library's collection of local history.

story time for kids and their parents, and as head librarian Tina Ely points out, these events serve as a place for incidental interaction: "The library is an important place for people to meet. We notice it during story times: The moms visit and talk about their children and people from the town will come in . . . " As the library began adding digital services, the staff stopped seeing some familiar faces. "A lot of people who consistently came in to get books or CDs," Tina says, "now get books electronically. I think that's great but there are people I miss visiting with because they're using electronic devices." But the library doesn't shy away from new technology; in fact, it provides classes on how to use electronic book readers.

There are things the library provides that are particular to the region, from books (both fiction and nonfiction) about the state of Wyoming to a collection of CDs that ranchers often check out during haying season to listen to in the cabs of their tractors to keep from falling asleep.

The public meeting room is free to use for those who "just keep it clean," according to Wanda Bond, who oversees the museum collection. It seats fifty-five "if you're willing to get squished" and is used by local businesses, the state veterans services officer, and the book discussion group, as well as for various unplanned emergencies. Recently the Forest Service used it as command center while fighting a wildfire.

(In March 2013 an unexpected seventy members showed up for the Shell Canal Company's annual meeting, which had to be moved to the Greybull Elks Lodge.)

The museum collection has grown from the initial exhibit and now includes dresses, historical firearms, and the doorknob from Adolf Hitler's bathroom at the Eagle's Nest, liberated by native son Clarence Harbaugh during World War II. Also of note is a collection of salt and pepper shakers formerly belonging to a Greybull hairdresser who asked patrons to bring her sets whenever they traveled. The shakers remained in her salon for years before finding a more permanent home in the museum.

This is the diary of life in America: the things that make a place unique, curated by individuals for their own myriad reasons and shared with others. It's a chance for all of us to say, *Here are the things that are important to us and that make us a society.*

Being in a small town is one of the library's biggest problems and greatest features. Tina Ely can give you examples of both: "Someone from out of town showed up at the library a few weeks ago and said, 'I'm trying to find my wife's ancestors up in the graveyard. How do I do that?'" Because Greybull is a small town, Ely knew the name of the cemetery's caretaker, and she knew his home phone number. So she called. He knew exactly where the family plot was. "We do get the darndest questions," she says, "and we do our best to answer them."

DOOR KNOB
REMOVED FROM HITLERS
BATH ROOM IN HITLERS EAGLE
NEST BY CLARENCE HARBAUGH
1945

One of the curiosities at Greybull's library is a doorknob purported to have come from Adolf Hitler's bathroom.

The disadvantages of a small-town setting are predictable: money; wanting to do more, put on more programs, buy more books; low population. There's a small pool of people to draw from, and sometimes events have a disappointing turnout.

But the library remains strong, buoyed by its constituents. If there's something she really needs, Tina assures me, the people will come through for her. Benjamin Franklin died thirteen years before the Louisiana Purchase and a century before Wyoming became a state, but I think he would have enjoyed this library. It's fulfilling his dream of a collection not just of books or even equipment, but of curiosities as well, weaving together into the essence of a community.

BETHANY DIAZ-PONS

My grandma used to tell me that I could read before I could talk. I've always loved reading and, as a librarian, I can encourage that love of reading in my community.

Library Assistant

DEGEN RESOURCE ROOM,
FLORIDA STATE UNIVERSITY

EMILY THOMPSON

Libraries are one of the few truly democratized places left in this polarized society. Librarians will help you get any resource you might need to accomplish your goal for free! (Or mostly free.) If you expand your mind beyond books, just think what we could help you accomplish!

Studio Librarian

UNIVERSITY OF TENNESSEE,
CHATTANOOGA

CHRISTOPHER LASSEN

Libraries are more relevant today than ever. In these challenging times, early childhood education is in great demand and trained children's librarians are being sought out in droves for their experience and expertise.

*Library Information Supervisor /
Children's Librarian*

BROOKLYN PUBLIC LIBRARY

MEGAN HODGE

The library is the only place anyone—poor or wealthy—
can go with a question and find a real person, capable
of reading between the lines, who can help find an
answer. Google doesn't work if you aren't even sure
yourself what you're looking for.

Teaching and Learning Librarian
VIRGINIA COMMONWEALTH UNIVERSITY (VCU)

EASTER DIGANGI

Think of us as information professionals who blast through the billion online search results and unlock access to databases and other key resources.

Assistant Treasurer / Treasurer Elect 2014–2017;
Volunteer, Friends of the Hampton Public Library

AMERICAN LIBRARY ASSOCIATION
NEW MEMBERS ROUND TABLE

DANIEL RONSOM

The greatest challenge libraries are facing is the apathy of the privileged. Libraries are busier than ever before, but then someone writes a "think piece"stating that "libraries are dead" and politicians cite it when slashing the library budgets. It's what actually happened to the Great Library of Alexandria. Yes, it was damaged by fires, but contrary to popular conceptions that's not what destroyed it. In fact, it was time and the apathy of its leadership that led to its slow decline. We can't let the apathy of today's leadership have the same disastrous effect on the libraries of today.

Institutional Services Librarian

CALIFORNIA COLLEGE OF THE ARTS

INGA HAUGEN

I am a proud librarian and informa-
tion scientist. I support the best
applied science of all—agriculture.
Land-Grant Libraries support the
research and the data to keep the
results available to build better
science. I communicate the raw
information, but also the stories
to make sure the humanity does
not get lost. Which means we
eat, drink, clothe ourselves; tend
our water, air, earth, and critters
(including human critters) based
on how well I do my job. Bring it!

Agriculture, Life Sciences, and
Scholarly Communication Librarian
VIRGINIA TECH

Peter Sagal

One of the most significant thresholds of my maturity was a staircase. Not college, or a particular teacher, or my first kiss (or more), but a fairly bland stairway in a fairly bland if cozy building in New Jersey, leading from the ground-floor, where the kids' books lived, up to the main floor of the Berkeley Heights Public Library.

If my childhood were a sitcom, the BHPL would be the "second set," just like Central Perk coffeeshop was for *Friends*: the place the central character goes so often you might as well just leave it built. Except in my case, of course, I was there alone, reading and searching and reading some more, so it wouldn't have made for very interesting television. How was I there so much, especially in my childhood years, before I could drive or even walk the two miles on my own? I assume I asked to go. It was my favorite place. It was filled with wonders, that basement room. Thousands of books, all of them colorful with remarkable treats within. It was my candy shop, and I was, literally, a kid in it. One day in the second grade I was home from school sick, and had by my bed seven—count 'em, seven—Danny Dunn novels from the Berkeley Heights Public Library, and I read 'em all, that day. I felt like the brave tailor from the story "Seven at One Blow," which I probably also read in a book from the BHPL.

But that stairway. It was a dark upward passage into mystery, replete with Freudian and Jungian meanings, which I couldn't understand because all the books about that sort of stuff were upstairs. I probably took a few preparatory trips up, to find my mother or father, or use the bathroom, or something, but in my mind, I seem to remember a real trip, around the age of ten, when I went upstairs to look at the science-fiction books. Juvenile sci-fi in the mid-1970s was a vanilla wasteland, with the aforementioned Danny Dunn and other wide-eyed young heroes with crewcuts saying, "Gosh, how did that happen, Professor!" If you wanted the real good stuff, the stuff with war and monsters and villains and S-E-X, the Larry Niven and Harlan Ellison and Roger Zelazny, you had to go upstairs, and up I went. And once I made that trip, I never went down again.

My memories of those years in the upstairs rooms—which were and are probably quite small, it being an underfunded municipal library in a small town—was that they were infinitely large, a Borgesian labyrinth, to use a term I (again) prob-

ably learned in that library. I remember reading Walter Miller's *A Canticle for Leibowitz* at a particular table. I remember my father handing me a copy of *The Egyptian* by Mika Waltari and saying, "I really liked this when I was your age," and reading it, and struggling with the fact that I really liked it, too, and how I remembered whispers of it years later when I stood in King Tut's empty tomb in the Valley of the Kings. I remember finding John Cleland's *Memoirs of Fanny Hill* and putting it back, and taking it out, and putting it back again. I remember looking out the window, not seeing anything of particular value out there, and looking back to my book.

To my shame, I do not remember the librarians. I'm sure there were many over the years who helped me find my books, and who were delighted to find a precocious young man interested in so many, and maybe even worried why I didn't get outside enough. Knowing me, I probably tried to make them laugh. Knowing librarians, I'm sure some of them did, out of genuine delight or pity or a combination of the two. And whoever they were, or still are—librarians are long-lived, and determined—I say thank you. Without you, I would still be at the bottom of that staircase.

Peter Sagal is a playwright, screenwriter, actor, and host of the National Public Radio show Wait Wait . . . Don't Tell Me!

CORAL SHELDON-HESS

Libraries provide many people with access to technology—not just physical access to computers and the Internet, but training and technological help. I live in Alaska, and in many communities here, pretty much the only Internet connection is at the library. It makes a tremendous difference in people's lives.

Web Services Librarian
UNIVERSITY OF ALASKA
ANCHORAGE LIBRARY

EMILY J. CREO

Library work often parallels artistic work. Cataloging, for instance, is much like being a classical musician; it requires discipline, adherence to tradition, and extensive knowledge of form and function. At the same time it also demands creativity, flexibility, innovation, and personal expression to make the work (or piece) accessible to those searching for (or listening to) it.

Head Cataloger
FOUR COUNTY LIBRARY SYSTEM

DEHANZA KWONG

Libraries are essential to the community. They provide a gateway to information that is reliable, something the Internet cannot always provide. They help the community by serving as a space of refuge for the homeless and homed alike. Additionally, the technology they provide is essential and irreplaceable. Enjoy the opportunities at your library for an amazing experience.

Librarian
RECENT MLISC GRADUATE

CHELSEA SHRIVER

Libraries are about people, not just stuff. The people who work in them and the people who use them make libraries what they are—awesome! Librarians care about you and we work to meet your needs in any way we can. Come talk to us. We're in this game for you.

Dual MLIS/MAS
(Master's of Archival Science)
UNIVERSITY OF
BRITISH COLUMBIA

TINA COLEMAN

Libraries and librarians are important because they can open entire new worlds to the people in their communities. Not just through books—everyone knows about the books—but librarians are super smart. They know things, and they know how to find the things they (and you) don't know.

Membership Specialist
AMERICAN LIBRARY ASSOCIATION

ERIN CATALDI

Librarians have to strive to stay relevant in a society that values a quick fix over working to find accurate information. Evolving to meet and exceed a community's needs and expectations is crucial. We've never been more needed, yet valued less and we need to change that.

Teen and Adult Services
JOHNSON COUNTY PUBLIC LIBRARY

SUSAN HESS

Advocacy is key. Librarians must showcase their accomplishments, especially school librarians.

Retired School Librarian
NEW YORK CITY D.O.E./
QUEENS COLLEGE

The Cathedral of Learning

Candice Mack and the Los Angeles Central Library

The Los Angeles Central Library is the crown jewel of the seventy-three locations in the Los Angeles Library system. Rising majestically from downtown LA, it holds six million books plus gallery space, learning areas, a 235-seat auditorium, 250 public-use computers, a food court, and more. The fiction collection boasts that it contains every novel set in California as well as every movie tie-in.

But it wasn't always like that. On the morning of April 29, 1986, the library had only two floors open to the public. The building was un-air-conditioned, and the electrical system was overburdened. Eighty-five percent of the library's holdings were held in off-limits areas known as the stacks.

On that morning at 10:02 a.m. someone whom witnesses describe as a white male with blond hair and a thin mustache, about 160 pounds, sneaked into the stacks on the fifth floor in the fiction section and set fire to the library. It went up like an over-wintered Christmas tree someone dragged into the backyard in April, still covered with tinsel and as dry and fragile as a brick of shredded wheat.

People had been warning for years that the central library was a fire trap, and the library had listened. A new state-of-the-art alarm system immediately went off. Patrons and staff evacuated the building within five minutes.

1530–1600 HOURS

Hose lines also used to protect the jackhammer crews. The floors were so hot that when water was applied to cool the area down, the water would actually boil.

—*Donald O. Manning*
CHIEF ENGINEER AND GENERAL MANAGER
LOS ANGELES CITY FIRE DEPARTMENT
OFFICIAL REPORT

Candice Mack from
the Los Angeles
Public Library.

The fire burned for seven hours and thirty-eight minutes. Flames destroyed four hundred thousand books and damaged nearly a million more. It took 350 fire-fighters from sixty fire companies to extinguish the blaze. Lost were irreplaceable works of art, the drawings in one of California's four patent collections, photographic negatives, and the soul of the city.

Miraculously, the building retained its structural integrity, and the next morning firefighters allowed more than a thousand volunteers into the building. Forming a human chain, they pulled what remained of the precious contents from the burned structure. Waterlogged books were sent to Texas and frozen in gigantic refrigerated warehouses to keep mold from setting in; they would be dealt with later. Other books were stored in the convention center. Smoke-damaged books were treated page by page. Many of the damaged books had to be rebound.

Among the atrium's artworks are three 18-foot chandeliers by Therman Statom. These symbolize the natural, technological, and spiritual aspects of life.

The Lodwrick M. Cook Rotunda, with murals by Dean Cornwell and ceilings by Julian Garnsey. Though it once housed cataloging, the rotunda is now ornamental, and spectacularly so. Cataloguing is done via computer.

One monstrous act of violence with a match took thirty seconds to furtively execute. It left the library shuttered for seven years.

When it reopened, eighty thousand people visited the first day to welcome it back. The new building was a cathedral of learning. Gone were the closed corridors and low headroom, the insufficient electrical power and lack of central air. Instead an eight story glass-roofed atrium welcomed visitors to a library experience: a massive shopping mall where learning was free.

When the US economy collapsed in the twenty-first century, Los Angeles looked to its library as an investment instead of a pool of money to be raided. "It's no coincidence," said City Librarian John F. Szabo in a letter to the community, "that after an economic downturn Angelenos would turn to the Library to create a better future for Los Angeles." Residents voted to expand services, add new

technology, and increase their collection. The Los Angeles Public Library now offers programs for adults including adult literacy, citizenship classes, and resources to help veterans cut through the sometimes mystifying bureaucracy surrounding benefits available for health, education, employment, housing, and the like. You can also take classes in understanding debt, bankruptcy, foreclosure, identify theft, investment, stocks, bonds, real estate, commodities, options, and futures, as well as retirement planning, education savings, and home buying.

Beyond just recommending books, the Los Angeles Public Library's Teen Web has homework resources, information about health and sexuality, and dealing with divorce.

The Maguire Gardens in front of the Los Angeles Central Library. The original building was constructed in 1926 and added to after the fire in 1986.

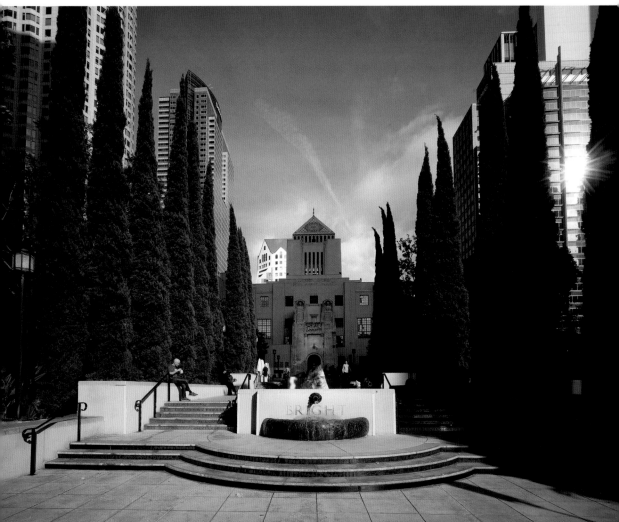

Senior Librarian Candice Mack is the systemwide coordinator of volunteer services. She oversees a host of programs including the Adult Literacy Program. This is staffed entirely by volunteers, who donate between one and two hours a week working one-on-one with adult learners who haven't acquired English-language reading or writing skills for a litany of reasons. "Their stories are always amazing and touching," Mack says, telling the tale of a woman who, as a young girl in school, was assaulted by a teacher. Her parents, being unable to guarantee her safety, didn't want her to return. And she didn't, eventually growing up, falling in love, getting married, and having children, all without learning to read. "What eventually tipped the scales for her," says Mack, "was a grandchild asking her to read them a book—and she couldn't. She'd had a flyer for the Adult Literacy Program, but that's when she decided to go. Now she's read books, many books, to her grandchildren." We, I think, collectively have an idea that libraries are books, and maybe that's how it used to be. "What don't people know about libraries?" Candice asks. "Well, a lot of it *is* about books. But it's more than that. It's about citizenship. It's what comes out of those literacy skills that you get from the library—even when it's puppets (Saturday at two p.m.!), [or] play or song. It doesn't have to be as staid as *This is a wall of books and this is how I'm going to read*. It can [come] through lots of other different channels. I wish that lots of other people knew about that."

Candice is also the project manager for Career Online High School. Los Angeles was the first public library in the country to give grants to patrons so that they could pursue their GED or high school diploma in a program that's done completely online. There are other types of literacy adults need in order to function, and the LA library also has classes on financial and health literacy.

The library looks to its constituents to assess needs and then tries to fill those needs. "One of our big programs," Mack says, "is the Path to Citizenship. We have citizenship corners in every library branch and agency—the Central Library and seventy-two branches. We've hosted citizenship fairs and processed hundreds of people to apply."

Can a library be the perfect library for the people it serves and be different from other libraries? In fact that is one of the things that makes libraries effective: that they form to the needs of their communities. In 1732 Benjamin Franklin jotted down a list of questions to propose to his Junto Club, to promote discussion. Here is his consideration of niches:

I suppose the Perfection of any Thing to be only the greatest the Nature of that Thing is capable of; different Things have different Degrees of Perfection; and the same thing at different Times.

Thus an Horse is more perfect than an Oyster yet the Oyster may be a perfect Oyster as well as the Horse a perfect Horse.

And an Egg is not so perfect as a Chicken, nor a Chicken as a Hen; for the Hen has more Strength than the Chicken, and the C[hicken] more Life than the Egg: Yet it may be a perfect Egg, Chicken and Hen.

—*Proposals and Queries to Be Asked*
the Junto, 1732

The Los Angeles Central Library has the capacity to be many things for its many patrons and to expand from traditional library services to meet extraordinary needs. "Before I became volunteer services coordinator," says Mack, "I was in Teen'Scape, which is the central library's teen department. We had a lot of teens whose nutrition and housing situation was unstable. There weren't any teens or tweens who said to me outright *I am homeless*, but we knew from seeing them all the time both in the library and in the Maguire Gardens out in front. Very early in the morning you'd see them hanging out there, and [during] times when they [were] supposed to be in school, and during the summer when we came to find out they weren't getting the free or reduced lunch at school that led me to doing a lot of food programs. I tried not to be obvious because I didn't want to call people out, but I wanted a way to provide some sort of sustenance to kids and families who might not be getting it. So I'd have programs like *Fun snacks you can make with your friends!* and *How to serve leftovers!* and I told every kid *If you are ever hungry, I will find you something to eat*."

Feeding the homeless wasn't something the Junto Club likely ever thought about when forming their library, but it is as an oyster to a horse in terms of being a perfect thing when that thing is needed.

The central library is close to Skid Row. Library staff noticed not just teens but entire homeless families who would come to spend the day before the shelters opened in the evening. The library has computers, Internet access, heating and air-conditioning, and a wide variety of entertainment resources. So the central library applied for a grant and partnered with the California State Library and the Los Angeles Regional Food Bank to start a program called Summer Lunch at the

Library. This provides food five days a week to anyone under eighteen years old. Volunteers from the community come and serve food, as do many of the staff. They use the food program to get people to sign up for summer reading and provide toys that encourage play and learning. The library is a public space and a safe space that doesn't prioritize legitimacy; it's a space that has transcended what may have been its initial intent. Did they serve lunch at the Library of Alexandria? Probably not. But they didn't teach you how to download ebooks onto your Kindle, either.

"Libraries are often thought of as book warehouses," Mack says, "but they're really not, they're really information warehouses. As technology has moved forward and these resources have become digital, libraries have gone with that to provide that information digitally as well as the tools to access that. It really doesn't help if no one can get to it, and it also doesn't help if there isn't somebody there to guide the user not just to how to use the equipment but also [how] to get to the information they're looking for. I think it's also important to have a physical place that you can go to—that if you're looking for X, you know that there's somebody out there whether they're online or in person who will help you find that information. That's just nice and reassuring. Also that there's no judgment there. *The information you're looking for isn't important* isn't something a librarian will say to you. We just try and help people get to their information. I would hope that's a reassuring feeling—that if it exists then there is somebody out there to help you find it, for free."

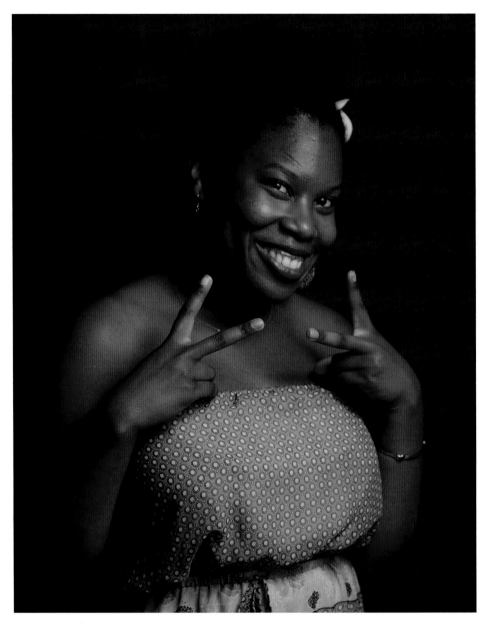

DEDRIA TILLETT

I believe that the biggest challenge to libraries is support from our community and especially our government leaders. The most important thing we provide is the freedom to gain knowledge. Books inspired me to become a librarian—truly, to share my love of them with others, like-minded or otherwise.

Youth Services Library Clerk
UPLAND PUBLIC LIBRARY

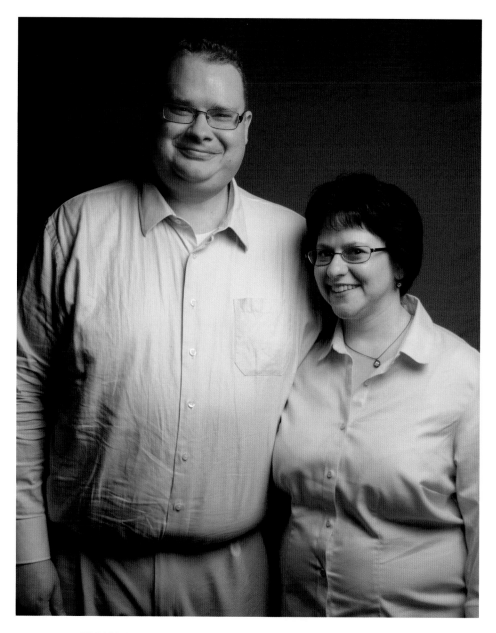

CHRISTOPHER HARRIS

School librarians are the curriculum
and pedagogical leaders driving
change in our schools.

Director, School Library

GENESEE VALLEY EDUCATIONAL
PARTNERSHIP SYSTEM

CHRISTINE FERRIS

Libraries got game!

Library Media Specialist

ARKPORT CENTRAL SCHOOL

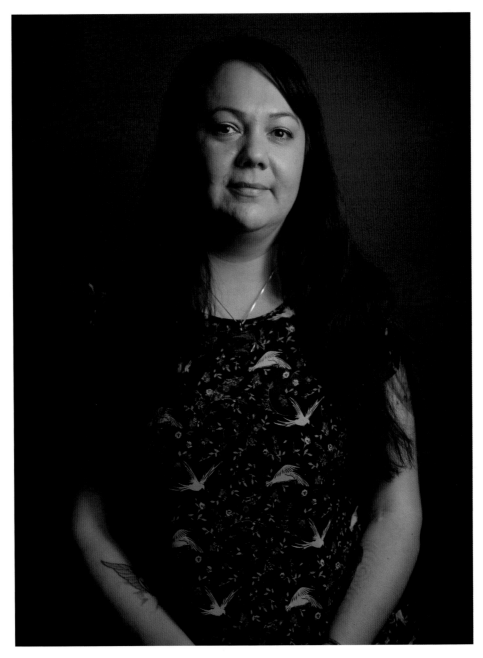

GENA PEONE

Libraries and archives have a great capacity to facilitate repatriation of knowledge with respect to Tribal interests. I am looking forward to continuing this journey, locating resources and bringing them home.

Archivist

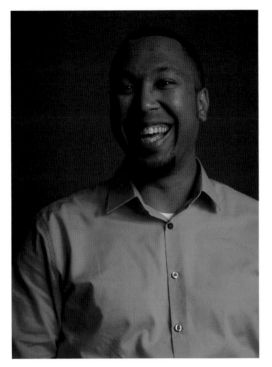

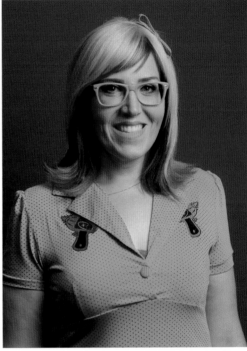

NICK GROVE

Many people think that libraries are an aniquated institution with minimal value to them personally. Libraries are not about the things we offer but are instead about helping people with their needs. Sometimes that's 3-D printing, or finding books or movies, and sometimes it having someone to hear you out. Libraries level the playing field for knowledge and access. In Meridian, we recently opened unBound in an old bank building, empty for several years. We've transformed this space into an essential component of our downtown revitalization.

Digital Services Librarian
MERIDIAN LIBRARY DISTRICT—UNBOUND

SARA CONEY

In the morning, I'm a rock star to a room full of preschoolers; midday, I'm a social worker, assisting a recently unemployed patron in finding resources; in the afternoon, I'm an educator leading kids through an after-school science workshop. Librarians serve so many purposes and wear so many hats, but all of them change lives.

Youth Services Librarian
SAN DIEGO COUNTY LIBRARY

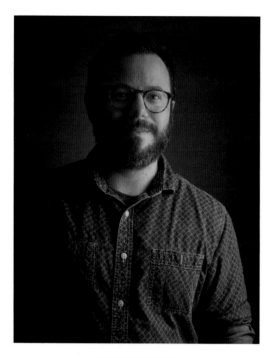

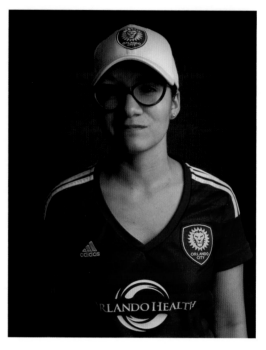

JOHN PAPPAS

At the Rapid City Public Library, I was a social worker, an educator, a storyteller, an advocate, and activist. Storytime Underground states it best: "Librarianship is not a neutral profession, and libraries are not neutral spaces." We have a responsibility to the most vulnerable members of our community; to attempt neutrality makes us complicit in their continued oppression. Instead, a library should remove hurdles to services and seek to be a safe and inclusive space for people of color, the homeless, LGBTQIA individuals, and any socially, racially, or culturally oppressed group.

Library Outreach Services Coordinator
RAPID CITY PUBLIC LIBRARY

AIDY SILVA-ORTIZ

Librarians still exist in the most unlikely places. I am fortunate and honored to be a hospital librarian. That's right! I work in a hospital and provide resources and services to hospital visitors, patients, and their families, as well as doctors, nurses, and fellow hospital employees. Reliable and credible information that improves our users' knowledge and even patient care is a universal right. We as librarians have the privilege to impact so many lives in so many different environments. Supporting librarians, whether hospital, public, or academic, means that you, in turn, are supporting the betterment of your loved ones, your community, and society as a whole.

Systems Librarian
ORLANDO HEALTH—HEALTH SCIENCE LIBRARY

CHRISTIE GIBRICH

One of the most wonderful things about being a librarian is seeing that spark that comes to a person's eyes when they realize, "Yes! Someone understands" or "Someone is listening" or "Someone cares," whether they're asking about a book, a movie, or a new program, or just figuring out how something works.

Librarian and Teen Specialist
TONY SHOTWELL LIFE CENTER LIBRARY
GRAND PRARIE LIBRARY SYSTEM

REBECCA LEONHARD

Libraries are the embodiment of lifelong learning.

Director of LAS Libraries

LEYSIN AMERICAN SCHOOL IN SWITZERLAND

SCOTT NICHOLSON

Libraries are a safe space where you can challenge your views about life.

Associate Professor

SYRACUSE UNIVERSITY SCHOOL OF INFORMATION STUDIES

TINA TAGGART

A school library is the heart of a school. To beat strongly, it needs an LMS.

Library Media Specialist

FOXCROFT ACADEMY

LEIA CASEY

Librarians help people find the information they seek. End of story.

Reference Librarian

MILLS COLLEGE

Samira Ahmed

Proust's window to his essential self was a sweet madeleine dipped in tea. Mine is the musty sweet smell of old books lining the shelves at the Batavia Public Library. When he tasted that madeleine, a delectable memory of childhood, an "exquisite pleasure invaded [his] senses." Though I didn't try to eat any of the books I checked out from the library as a child, I consumed them. They filled me up, opened doors, gave me answers to questions I didn't dare ask anyone else.

When my family immigrated to America from India in 1972, I was a chubby-cheeked one-year-old. Our story is like the many immigrant stories that populate the ethos of America. My parents arrived—weary but bright-eyed with a baby in tow—ready to roll up their sleeves and put their hands to work while searching for footing in the fertile soil of the American Midwest. My mom, a jewel-toned sari slung over her shoulder and braid down her back, and my dad, sleek-suited and mustachioed on trend, stepped into the crucible of the great American experiment, naively, perhaps, yet in earnest. But that kettle was boiling with the unsettled political environment of the early 1970s, economic upheaval, and ethnic and racial tension. A world not so different from today.

And becoming American didn't come with an easy how-to guide.

My parents struggled to preserve their own beloved culture while fitting in and exploring a new one. Meanwhile, I went to a small-town elementary school as one of the only brown kids, one of the only immigrants, and absolutely the only Muslim in my class. When everyone but you returns from winter vacation with stories of Santa and stuffed stockings and presents on Christmas morning, you smile and nod, silently, while a tiny piece of you retreats so you don't get crushed. A seed of doubt grows and makes you wonder if you really can grow up to be anything you want like everyone else seems to think. How is that possible when you're different from everyone? When you're always starting a few steps behind?

My parents couldn't help me navigate the identity politics of grade school and middle school; they'd never experienced it. I needed that how-to manual. And I found it. In the library.

Not a manual, exactly, not a checklist. Something far better: books. Stories of other kids who felt alienated and different, who had dreams and doubts. I found

Laura Ingalls Wilder, who in virtually every way was different from me but who shared an experience: the feeling of being an outsider and struggling to find her way in one new place after another. And she also had it a lot worse than I did. Before Laura, I never realized how damn lucky I was to have indoor plumbing and heating and refrigeration. Like Laura's parents, mine also worked to ensure we had food on the table and a solid roof over our heads. Buying books wasn't always an option. But I could check out *On the Banks of Plum Creek* and the librarian would take my library card and stamp the due date in the back of the book and hand it over with a smile, like she'd already done the dozens of other times I checked it out.

My library card was power. I kept it stashed in its worn manila pocket, a portal to other worlds. In 1980 I discovered mysteries. Nancy Drew and Agatha Christie and *The Westing Game* and cold cases of Victorian England. And because some of the provocative book covers would draw suspicion from my very protective mother, I would read the books at the library—an old Victorian mansion with a reading room that had comfy chairs and an enormous fireplace and lots of other corners where clues could be discovered, accusations aired, and criminals brought to light. The head librarian knew me by name and would let me lounge around for hours in the summer, books and air-conditioning my ultimate refuge.

But for me the library wasn't only a place for checking out books; it was the heart of our community. During Summer Reading Club, my best friend and I would race to read and report on our books, hoping to be the first to reach ten books, then twenty, then thirty, earning free scoops at the local ice cream shop for our efforts and our names in the paper and subsequent pats on the back and cheers from neighbors thanks to our newly minted fame. The librarians asked me to teach other kids how to write book reports and would sometimes send kids to me for book recommendations. I wasn't just needed. I was wanted. I belonged.

I searched through stacks, fingers running along cracked spines, for the stories that spoke to me. But in the end, I found myself. I was a reading girl. And it was delightful. At the library, I could discover all those pieces of myself that were sometimes hidden away. I could ask questions and find answers and no one made fun of me because I could never figure out if what comes around goes around or if what goes around comes around; instead a librarian gently guided me to discover the answer for myself.

Over the years, my hometown library was where I did research, studied, huddled in corners with my friends skipping to the "good" parts of the Judy Blume books our parents wouldn't buy us, filled out college applications, tutored the cute boy I had a crush on, registered to vote.

Later, when I taught American literature in high school, I asked my students to bring in an object that defined America for them. One sixteen-year-old, whose family was part of the wave of Russian refugees in the early 1990s, brought in his library card. When they were finally settled in their permanent home, he told the class, one of the first things his parents did was take him to get a library card. In America, his mother had explained, you can check out *any* book you wanted. A library card, he said, was like carrying freedom in your pocket.

Hearing my student speak so eloquently and simply about libraries crystallized for me something I'd started to take for granted as an adult. Libraries are so much more than buildings that house books. Libraries represent the free exchange of ideas dating back to Alexandria and the third century BCE. They archive the human experience, yes; but they also give life to it. They connect people within communities and open doors to the unknown. Libraries provide mirrors for new immigrants—a home where they can find themselves and realize that the once elusive "Americanness" is the very quality that led them to these foreign shores.

My library helped me find answers to my questions, which then led me to more questions and more answers, a winding journey that is with me still. When you enter a library, you walk into a shared civic space, engaging in a social contract with every member of your community. Libraries are a gateway and a cornerstone to our democracy.

Libraries lift us up. Bring us together. Help us to know our essential selves. They nourish us. Fill us. And they are delicious.

Samira Ahmed was born in Bombay, India, and grew up in Batavia, Illinois, in a house that smelled like fried onions, spices, and potpourri. She currently resides in Chicago. She's lived in Vermont, New York City, and Kauai, where she spent a year searching for the perfect mango. A graduate of the University of Chicago, she taught high school English for seven years, worked to create over seventy small high schools in New York City, and fought to secure billions of additional dollars to fairly fund public schools throughout New York State. Her creative nonfiction and poetry have appeared in Jaggery Lit, Entropy, Claudius Speaks*, and* The Fem*. Her first novel,* Swimming Lessons*, will be published in spring 2018 by SoHo Teen, an imprint of SoHo Press.*

ANTHONY J. ELIA

Defining libraries today and tomorrow is paramount! The world changes all the time and so do people and the needs in our communities. It is also important to think about the role and future of the physical book. I work in a theological library and this is still important for theologians and religious scholars. We must work collaboratively and with all communities—the local, the regional, the national, and the international. This will create stronger bonds of cooperation and afford us greater understanding of not just our profession, but humanity in its most profound moments.

Director of Library & Educational Technology

CHRISTIAN THEOLOGICAL SEMINARY, INDIANAPOLIS, IN

HEATHER FIRCHOW

Libraries are for everyone. We have materials, resources, and programs for users of every age, race, and gender. If you aren't using your local library you are just throwing money (your tax dollars) away!

Senior Librarian

TORRANCE PUBIC LIBRARY

JENNIFER BAKER

Libraries aren't just about information and books. While that is still our core we are also about community. We provide space for individuals to discover who they are and what they want to become and we offer the tools and resources you need to succeed. For free!

Librarian

NAPA VALLEY
UNIFIED SCHOOL DISTRICT

BECCA RASNIC

My favorite thing about librarianship is showing someone that a public library is so much more than they ever imagined. I am there to help people succeed at what they want to do and be.

Information Services Librarian
JONESBORO PUBLIC LIBRARY

LAURA DELANCEY

Librarians have a vital role in teaching information literacy, curating and facilitating access to content, and advocating on behalf of our patrons a myriad of issues, including accessibility, open access, net neutrality, DRM, and more.

Electronic Resources Coordinator
WESTERN KENTUCKY UNIVERSITY

COURTNEY YOUNG

Why libraries? Innovation, creativity, inspiration, diversity, community.

2014 President of the American Library Association

PENN STATE GREATER ALLEGHENY LIBRARY

EMILY LOPEZ

My library is in a poor, Hispanic community. Families can't afford to buy books and do not have a tradition of reading and striving to attain education. Our library is a community focal point that provides access to online homework help, baby and toddler story time, weekly teen creative activities, and access to books for knowledge and fun.

Young Adult Librarian
LOS ANGELES PUBLIC LIBRARY

MARJORIE RAMSEY

Mere access to information is not a twenty-first-century problem. It's about having the digital literacy skills to know how to navigate the vast amount of information available, sift what's valuable, and use it.

School Librarian
CAPITAL SCHOOL DISTRICT

Archiving the Past: Texas A&M and the University of Iowa

Plus George R. R. Martin Gives Me Some Thoughts on Libraries

I asked George R. R. Martin if he wanted to participate in this book and since I didn't want to be *the guy who had George R. R. Martin write something that wasn't The Winds of Winter* I offered to do it in the form of a conversation. He told me he was having a party at Worldcon in Kansas City, Missouri, and if I could come out and photograph his party, he'd be happy to talk to me about libraries.

One of the main purposes of Worldcon is to give out the Hugo Awards— they're the Oscars of science fiction. George himself has won eight Hugo Awards and lost seventeen. In 1976 he had won exactly none and at that year's Worldcon he lost two, one to Larry Niven and another to Roger Zelazny, and, since celebrating is better than weeping drunk in a gutter, he decided to throw a party to celebrate not winning—thus was born the Hugo Losers Party. Jugs of Gallo wine were procured, and George invited everybody who'd lost a Hugo (and everybody who hadn't been nominated). The party raged on in George's hotel room. *Locus* magazine would later call it the best party of the entire convention. George has continued to host the Hugo Losers Party ever since, and as his fame and fortune have grown, so has his ability to throw a killer party. The 2016 Hugo Losers Party was held at an opulent 1920s theater in downtown Kansas City, with a theme of "speakeasy." The bar was paid for by Random House with special *Game of Thrones*–themed drinks. There was a band, people danced and stayed up late, and the pain of not having won science fiction's greatest award was assuaged by the knowledge that you were at the best party in town.

The next day George and I talked about libraries. Did he remember his first? Like every writer I've talked to, he did.

"Bayonne, New Jersey, right by my school, there was a branch library. It was in an old storefront and it had full, plate-glass windows and librarians sitting right inside. It was quite small, but right inside the door there was a science-fiction section, which you could tell because there were little rocket ships on the spines. And I started reading the books in that section; I read pretty much all of them. There weren't many."

When not at the library he watched television, still with an eye toward science fiction, which was flourishing in the post-Sputnik days—*The Twilight Zone*, *Flash Gordon*, and *Buck Rogers* ruled America's imagination. George wrote with a typewriter on his mother's kitchen table. The first thing he had published was a letter in the back of a comic book, which led to reading fanzines, corresponding with writers in fanzines, and eventually realizing that he could write better stories than some of the people in fanzines, which led to getting published in fanzines, and then in genuine science-fiction magazines. Which led to a career.

In 1992 librarian Steven Smith at Texas A&M University convinced George to donate his papers to the library—four years before the first *Game of Thrones* novel would come out. By that time, the collection at Texas A&M was already extensive and well known. "The collection goes back to the mid-1970s," says Cait Coker, a former curator at the archive. "There were several librarians involved: Anthony Hall was the instrumental one, along with Vicky Anders and Marjorie Gerber. They saw ads for a collection of science-fiction pulp-fiction magazines and they wanted the library to buy them. The library administrator said, 'If you can find two departments on campus that would be willing to sign off on this as a research collection, we can do it,' so Hal went to the engineering department—because engineers really like science fiction—and he went to the English department, and they signed off on it. They got two thousand issues of *Amazing Stories*, *Astounding Stories*, and a few others. And then they worked from there to grow the collection.

"There was an official dedication in 1977 that James Gunn spoke at; he was working on establishing the Gunn Center for the Study of Science Fiction in Lawrence, Kansas. The early 1970s was a time when science-fiction studies was becoming a serious thing. The journal *Extrapolation* began publishing in 1959; in 1973 another academic journal, *Science Fiction Studies*, began. Up until that point nobody paid attention to the pulp magazines, [but] then people said, 'Oh! these

things are falling apart and nobody is collecting them. We need to get in on this.' That was the origin of the collection."

The process of acquiring the Martin papers was long. The Cushing Library first reached out to George in 1986, when he was in town for a convention in the midst of a tour. Librarian Donald Dyal made his pitch, as he related to the *Houston Chronicle* in 2014: "If you don't find a place to put your stuff, it will dissipate at some point. Someone will pick it apart. They'll pick low-hanging fruit and it won't exist as an entity. It will exist as separate things that people will sell, because they're interested in the money, not in your work." That resonated with George, who considers himself a pack rat, and in 1992 he agreed.

Every time George prints out a copy of a manuscript to send to his editor, he prints out a second copy and sends it to the Cushing Library, which means that in the future scholars can visit the drafts and see how the story evolved. One of the many jobs of libraries has traditionally been preserving physical objects.

"University libraries, in particular, *are* the repository of all our history, and should be," says Martin. "For science fiction and fantasy, it's relatively recent that anyone preserved this material at all, because for much of history the genre was beneath the notice of respectable scholars or of librarians or academics and no one wanted to preserve this stuff. It was 'junk,' just 'throw it in the trash,' who cared about a 'bunch of pulp writers'? But with the rise of popular-culture courses and science fiction getting some respectability, now there are several significant collections that will, hopefully, preserve all these papers and such for posterity, and the books themselves and all of that. And Texas A&M is one of those. They have a superb collection and they have great physical facilities to hold it, which is important, too, when you're dealing with paper. And old paper—it can't just be put on a shelf. It needs temperature control, environment and fire suppression systems, and all of that good stuff that they do have at the best archives."

It's not just books. George sends all sorts of stuff to Cushing—replica weapons, calendars, games, action figures, whatever. And they add it to the collection, which started with 28 boxes and now comprises more than 288.

This is an area of contention among librarians.

"When it comes to tensions between archival and circulating collections," says Cait Coker, "there is a fundamental disagreement about access. Archivists believe that the specific object, whether book or zine or something else, needs to be materially preserved, and so there are always conditions of usage and access—looking at

an item in a reading room, no pens, et cetera. With circulating collections, access to the content is the most important issue, with limited acknowledgment that content changes depending on text."

It becomes a question of *what is the object*—the text or the medium? Edgar Allan Poe's "The Raven" is a series of words that can exist independent of a physical medium. The poem can be written in the Roman alphabet or Braille, or tapped out in Morse code; it can be recited, memorized, and passed from person to person. But every time it's written or recorded, that physical object is unique—from Poe's handwritten manuscript, to the first printed copy in 1844, to the elaborately illustrated version by Gustave Doré (or an inexpensive paperback, or even words scrawled on a bathroom wall), to being performed by an actor and recorded on VHS tape or DVD. Each of these physical objects not only gives you Poe's words but also conveys something about the time and place it was created; it might be useful to people studying "The Raven" itself, as well as topics such as bookbinding, digital media, printing techniques, or the durability of a particular type of paper. So . . . is the function of the library to preserve the physical object or to get you the words on that object? A non-circulating copy of a book takes up shelf space that can't be widely accessed by ordinary patrons.

There will always be battles (or as Coker says, "Spats verging into wars") about how to best use available resources. Archivists are gambling that things that seem useless today will be priceless tomorrow—and that by providing a safe space and time, the objects will incubate into something useful. Martin's collection at Cushing has certainly incubated as he's risen to be one of the most famous writers in America, so much so that his time, even at Worldcon, where he is ostensibly relaxing, is blocked out to the minute.

"I filmed an interview for my German publishers a few days ago," he tells me, pulling on his beard, "and they used the Kansas City Public Library, a few blocks from here, as the site. It was a gorgeous old building. They wanted to do this thing where I would wander the stacks and discover books that had been influential to me and talk about them, so of course I gave them a list of books that I could discover and at the top of the list was Heinlein's *Have Space Suit—Will Travel*, the first science-fiction book I ever read. And they didn't have it! That shocked me. I mean, this is Kansas City, this is Robert A. Heinlein's hometown, he's the most famous science-fiction writer of his generation and certainly the most famous science-fiction writer ever to come out of Kansas City.

"They ought to have a bust of him there and they ought to have every one of his books, maybe first editions signed and special collections and then stacks overflowing with all of his books . . . I would hope that back in Bayonne, New Jersey, the library has a lot of my books on display, but I can't tell anymore."

With limited shelf space and new books coming out every day, the decision on what to keep, what to discard, and what to buy isn't one that librarians make lightly or, nowadays, on their own. Mallory Austin, a librarian from Middlesex County Library in Ontario, Canada, says: "We increasingly automate this process, using software like Decision Center to isolate recommendations for weeding, shelving allocation, floating collections, et cetera. That said, these are simply suggestions, and the librarian has the final say. This is one of the many ways in which a real-life tech-savvy librarian is still essential to providing excellent library service. When configured properly we can use collections development software to great benefit. But at the end of the day, we need to consider a vast array of variables while developing collections."

It may be ironic that in this, Heinlein's future world, a robot may have been partially responsible for some of his books being removed from the shelves—though such harsh realities may be somewhat mitigated by the fact that Heinlein's great artificial-intelligence work, *The Moon Is a Harsh Mistress*, exists at the Kansas City Library as both an electronic book and a digital audiobook. Both are available using the Overdrive app, which allows patrons to check out electronic resources without leaving their homes. When asked in 1949 to predict what life would be like in the year 2000, Heinlein was mostly off the mark. He correctly predicted cell phones but missed that they would also serve as book readers.[4]

Whether or not they've forgotten him, the library, and its limitations, were a big part of Heinlein's life. His wife, chemist Virginia Heinlein, wrote in her book *Requiem*: "By the time he was in his early teens, Robert Heinlein had read all the books in the Kansas City Public Library on the subject of astronomy . . ." Similarly, the young George R. R. Martin, far away in Bayonne, New Jersey, twenty-five years later, had read all of Heinlein's own books, which had been fueled by the astronomy section in Missouri. George had come full circle when he hoped to pull a copy of *Have Space Suit—Will Travel* from the shelves of the library that, in a way, was

[4] "Your personal telephone will be small enough to carry in your handbag. Your house telephone will record messages, answer simple inquiries, and transmit vision."

the progenitor his own success. He was fifty years too late to see a young Robert Heinlein stand in the astronomy section, look at the shelves, and realize that he had read every single book and needed to move on.

Heinlein wrote glowingly of the library in his book *To Sail Beyond the Sunset*: "In the 1900s Kansas City was an exciting place . . . Kansas City had 150,000 people in it . . . The public library had (unbelievable!) nearly half a million volumes." Both Robert and George were big writers from small places who walked into libraries and were taken away, launched, into the future. Both dried out the small sections available to them then struck out into the world looking for (and eventually creating) more. Perhaps there's something to be said for a library collection being incomplete. How many times have you heard someone say, "I read most of the books my library had on the subject"? My college had two photography classes, and after I took them both I was left to strike out on my own. Maybe there's something to that.

The curator of science-fiction and popular-culture collections at the University of Iowa, Peter Balestrieri, looks for the small things that nobody else is saving.

Fantasia, illustrated by editor Lou Goldstone. Fantasia lasted for only three issues, published between January and July 1941. Each issue featured three stories, three poems, three articles, and an editorial.

Around the world librarians are fighting to save collections of things people don't necessarily think are worth saving, and making the case for using up valuable shelf feet of storage space to keep them.

Which brings us back to the fanzines—the first place where George R. R. Martin was published and the fire that fueled his early career.

At the University of Iowa, the curator of science-fiction and popular-culture collections (yes, that is actually a job), Peter Balestrieri, is looking to digitize ten thousand fanzines from the twentieth century documenting the birth of the genre. The fan-produced mimeographed magazines were collected by James "Rusty" Halvern starting around midcentury; they contain writings from people who would later become some of the most important writers in the field. "Modern" science fiction has only been around for a hundred years or so, and librarians and archivists are having a second chance at collecting literary history while it's still possible to collect things.

Balestrieri's collection includes a number of fan-generated archives as part of the University of Iowa's "DIY History Interface"—which, among other things, includes cookbooks going as far back as the 1600s. This is the very heart of Ptolemy's idea of standing on the shoulders of everyone.

Some of those small shoulders turn into big ones, and Peter's collection helps chart the paths that people take. "Fanzines are just one important part of the bigger history of self-publishing," he says. "Brochures, broadsides, leaflets, church bulletins, church cookbooks, literary journals, and fanzines, et al., contain a wealth of information about the details of everyday life unavailable in other, commercial forms. Fanzines in general, and science-fiction fanzines in particular, are a critical tool in the hands of scholars and researchers who seek

to understand how genres develop and the communities that develop around them. Science-fiction fandom has always functioned as the minor leagues for the genre's pros, contributing for going on eight decades to many of the best authors, artists, editors, and publishers. No other genre has been as heavily affected by its fans—and [it] continues to be, through the continued presence of pros at fan events, simultaneously present as both pro and fan." As in Steve Tinney's library of clay tablets, it's the small things that are interesting. The Sumerians didn't write down the commonplace things, so while we know all about their major economic transactions—loans and house sales—we know nothing about their personal lives, habits, daily life, or informal communications; we have letters from the kings but none from potters, weavers, or fishermen. In the Tablet Room the most insignificant descriptions of mundane things would be the most valuable, because nobody collected them.

If Peter could get in a time machine and go raid history, he wouldn't go looking for great works of art but rather the small things. "Ephemera," he says. "Cheap things, things that don't last. Photos, diaries, letters." He's less interested in Shakespeare's plays than in the posters the Globe Theatre used to advertise them. We have Shakespeare plays; we don't have those posters. "History from the bottom up," Balestrieri calls it. And indeed, these little things can become incredibly important. Arcadia Publishing has made something of an industry publishing books of photos that are essentially antique real estate flyers printed on postcards in the early part of the twentieth century. The raw material of their Images of America neighborhoods series were often meant to advertise new homes but have become an invaluable glimpse into history. There are a thousand photos of the Eiffel Tower as it looked in 1927, all found easily enough for anyone looking, but there are none of my house.

"Everybody in special collections librarianship is gambling on what will have research value in the future," says Balestrieri. "My department started gambling on the importance of fan-related materials long ago, and I inherited that bet. I have raised that bet quite a bit, more in space than in dollars, taking in donations of large collections from fans of everything related to fan activity and also large book collections, authors' and artists' papers, et cetera. It's all a gamble. Other institutions are gambling in different ways with different kinds of collections. That's what makes us hopeful of preserving as much as possible: We're not all collecting the same things."

Science fiction is often a refuge and an escape for nerdy kids who don't fit in. In fact that's something that's celebrated at Worldcon, where all those nerds have grown up and are sometimes getting their revenge with their success. In *A Song of Ice and Fire* there are libraries, for sure, mostly underutilized, though some spectacular. Two characters are mentioned in conjunction with libraries more than any others: Tyrion the dwarf and Sam, banished from his father's house for not being Prince Charming material. I ask George about why certain characters appear to be around libraries more than others.

"Well," he says, "Tyrion in particular says that *books are a weapon. As a sword needs a whetstone to keep it sharp, a mind needs books*, and his mind is his weapon. He has no physical prowess in a world that values and esteems physical prowess above all, so he has to fight the knights and the lords with his mind. And books are a way to keep the mind sharp, keep the mind flexible, test yourself against other voices, other ideas, and learn things. Because you never know what you're going to need to know in some future time."

So librarians are constantly having to make choices about what to keep. The books of their hometown's most famous writer? Or something nobody else has? Sometimes they choose wisely, sometimes they don't. But at each step of the way, there's a person carefully weighing these decisions: a librarian.

Game of Thrones presents a world preoccupied with war and power and one in which libraries, for the most part, are facing the problems that Alexandria faced at the turn of the age. Armies have become the indispensable thing that money is raised for and money is spent on. If there are piles of books but no one to tend to them, we are without guidance. What happens, I ask George—since he's thought about it—in a world where libraries, and specifically librarians, start to go away? It's a world that we already live in.

"Librarians are, of course, very important, and most of them I know are very dedicated to their jobs and love their libraries, love books, love knowledge. The challenges that libraries face, as I can see it—and I'm an outsider—[are] financial. They're simply not being funded sufficiently. You know, I'm constantly seeing bond votes in New Mexico. There will be a bond vote for senior citizen centers, and there will be a bond for a new road or a new bridge, and there will be a bond for the libraries, and the senior citizen center always passes, the roads and the bridges always pass, and the library always fails. People don't like to pay taxes, and sadly for most of the population they don't look at libraries as something worth paying

more taxes for or worth doing bond funds for. So libraries are under huge financial pressure. The librarians are as a rule not tremendously well paid—it's a profession you do for the love of it—and they're under constant pressure in terms of their facilities. When I was a kid, I don't know where I got this idea, but I just had the view that libraries accumulated books and were always adding more and more and more books. I never thought libraries would get rid of books, and when I learned that there were library sales where you could buy these books for ten cents each it kind of shocked me. The idea that you would donate your books to the library and they would be there forever and they would be preserved—that's a very appealing idea for me. The idea that you run out of room and suddenly you have to get rid of that book is bad. I guess I do have this view of them as these repositories of culture and knowledge and not as popular institutions to fulfill that. I know that when my new book comes out a lot of libraries are going to buy twenty copies of it, and that's nineteen books by other writers that they're not going to buy because they're spending the money on twenty copies of my book. Although it's not to my interest, I would rather they buy one copy of my book and buy nineteen other books, but everything is driven by what circulates, what customers want, customer service. But I'm not sure every institution in our society should be geared to customer service, if you know what I mean."

EDWIN MAXWELL

Libraries are the centers of the community; the last place to receive truly unbiased information. Libraries are the poor man's university—the place where you can have access to all the knowledge of the world for free.

Library Information Supervisor

FLATBUSH BRANCH,
BROOKLYN PUBLIC LIBRARY

BREANNE KIRSCH

Libraries are one of the few places that actually want people to find what they need for free. University libraries want to help students become self-sufficient researchers so they can find the research they need for classes, the workplace, and life in general.

Public Services Librarian

USC UPSTATE

BETSY DIAMANT-COHEN

Libraries are essential for democracy. They are a place where all people (children and adults) are welcome, regardless of race, religion, sex, economic status, or employment. Public libraries are signs of a healthy society.

Library Consultant & Trainer

MOTHER GOOSE ON
THE LOOSE, LLC

CEN CAMPBELL

Children's librarians are responding to the need for "media mentors" for families with young children. We are mobilizing to support families in the digital age.

Founder
LITTLEELIT.COM

EMILY BATISTA

One of the greatest challenges facing libraries today is ensuring that funding agencies and community members know how much more we do than buy and lend books. Far too many retain an out-of-date version of the library and think it is no longer the important institution it is. We have an obligation to communicate our value to everyone or we risk being ignored to the detriment of all users who depend upon us. Libraries provide valuable services to their communities that improve lives and build better futures for the whole country. We can't take for granted our continued existence without effective communication.

Head of Resource Sharing Services
UNIVERSITY OF PENNSYLVANIA

AUDREY PEARSON

The most powerful thing a person can do is be informed. Librarians ensure that everybody can be powerful, regardless of money, race, gender, or circumstance.

Catalog/Metadata Librarian
YALE UNIVERSITY

KERRY WEINSTEIN

While most of the world has gone digital, not everyone has made that leap. Libraries are vital in helping people get online and librarians teach them how to use the Internet to its full potential.

Reference Librarian
HOBOKEN PUBLIC LIBRARY

LALITHA NATARAJ

Ideally, the library is an equalizer, where people can go and not feel judged. Even if this isn't always the case, library staff can and should advocate for libraries as equalizing community spaces.

Youth Services Librarian
ESCONDIDO PUBLIC LIBRARY

NANCY KIEFER

Breaking the stereotype is one of the greatest challenges facing libraries today. Getting people to understand that we are technology specialists as well as experts on books and authors.

Teacher-Librarian
APPLETON AREA SCHOOL DISTRICT

Sangu Mandanna

Picture a young woman. She's twenty-two, just out of university, and she hasn't yet found a job that pays. She's in a brand-new city with a whole lot of rent to pay, she and her fiancé are barely making ends meet, and she has her seventh manuscript making the rounds of literary agents on both sides of the pond with no luck yet. She's bright-eyed, hopeful, certain the world will fall at her feet.

Only it doesn't, of course, because the world doesn't tend to just fall at one's feet and frankly it's even less likely to fall at the feet of a completely broke brown girl living thousands of miles away from her family and hoping somehow to make it by doing what she loves best: reading books, writing books.

On those hot summer days as she trawls the city looking for HELP WANTED signs in shop windows, she finds there's nowhere to go. Her fiancé, who finished university the year before she did and who does have a job, is at work; she doesn't know anyone else in the city; most of her emails seem to be rejections or recipes from her mother; and, to be perfectly blunt, she really can't afford to spend her days in the nearest Starbucks paying politely for a coffee every hour. So her options are search shop windows or go home and read the newest rejection.

Shop windows it is.

And then she sees it. With a glass roof that points to the sky and big wide doors leaking chatter and noise into the square, it's a library. It's gorgeous and quirky, but she doesn't really notice any of that until later. She notices the books. It's been a few months since she's had a chance to read anything new and she kicks herself for getting so dejected and disheartened since she arrived in this new city that she didn't think of this obvious haven sooner.

A library. Where you can read for free. Where toddlers discover their first books and pensioners nurse cups of tea over an old paperback and teenagers sneak away from the beer and cider in the park to read instead. Here's a place where you can just *be* for free. And there really is no way to overstate how much that word, *free*, matters when you have no money to spare.

She goes inside. She finds a book about a fantasy kingdom and an enterprising young heroine and lots of poison. Yes, years later, she remembers that. That first book. She starts to read.

And everyone who loves books will tell you what happens next:

She finds she isn't alone anymore.

That was almost seven years ago. Just months after that day, I signed with an agent and sold my first book. Two years later, I walked back into the glass library and had the tremendous pleasure of spotting a girl reading my book. (I really wanted to walk over and tell her I wrote it, but I'm intimately familiar with the wrath of the interrupted reader and so I left her to it.)

The thing is, I didn't walk into that library that first day by accident. It didn't happen in a vacuum. I walked by countless parks, rivers, cafés, and pretty benches during those summer days in my new city (now less new and much more loved) and gave few of those places a second glance. The library might have gone the same way, vaguely noticed and then dismissed, if I hadn't grown up in an inviting, enormous world of books and libraries. Of people who made both wonderful.

My parents are avid readers and I started reading early, rapidly deciding that even Mum and Dad didn't have enough books in the house. On cue, the library. My school, where I spent most of the first eighteen years of my life, had a real passion for instilling in children a love of reading. I'll never forget the scary head teacher who made children quake in their shoes as they passed by her in the corridor but who, when she opened a book in the library and began to read out loud, had them (us!) flocking to her in seconds.

The school had a warm, friendly, cheerful library packed full of brightly colored books and an almost absurd number of Victoria Holt historical romances (and believe me when I say I had read every one by the time I graduated), and just as important, the library had warm, friendly, cheerful librarians who were always there for a chat or a laugh or a helpful nudge in a new direction.

Specifics vanish with time and memories blend together, but feelings stay with you. And what I remember most about libraries growing up was an overwhelming sense of *largeness*. Books make worlds bigger and libraries magnify that a hundredfold. Libraries were easy for me even when the rest of the world wasn't. They asked nothing of me and gave me so much. They made my world

big and they made it full. It's difficult to feel alone and empty in a world that's so full.

It was the fond memory of that fullness, that largeness, that immense *not aloneness*, that drew me into the glass library that afternoon six years ago. I had nothing to give, but the library didn't care. It wanted nothing from me. And it gave me a big, full world for nothing.

Sangu Mandanna was four years old when she was chased by an elephant and wrote her first story about it and decided that this was what she wanted to do with her life. Seventeen years later, she read Frankenstein. *It sent her into a writing frenzy that became* The Lost Girl, *a novel about death and love and the tie that binds the two together. Sangu now lives in England with her husband and son. Find her online at www.sangumandanna.com.*

Afterword

Home Again

It's been almost three years now since I photographed my first librarian, Megan Threats, who works at the AIDS Library of Philadelphia, and two months since I took my final portrait: Majed Khader from Marshall University. In betwixt I've had the opportunity to meet and talk to more than 350 librarians about the amazing things that they're doing.

Ptolemy started his library by fiat and Franklin, his, by incubation. Did the pharaoh imagine that the scholarship at Alexandria would help individual farmers in the outskirts of Swenett, far removed from his cosmopolitan granite splendor in the north? We may never know, but Franklin assuredly did. In his own prototypical rags-to-riches story he credits the library as critical to his success:

> This library afforded me the means of improvement by constant study, for which I set apart an hour or two each day, and thus repair'd in some degree the loss of the learned education my father once intended for me. Reading was the only amusement I allow'd myself. I spent no time in taverns, games, or frolicks of any kind . . . my father having, among his instructions to me when a boy, frequently repeated a proverb of Solomon, "Seest thou a man diligent in his calling, he shall stand before kings, he shall not stand before mean men," I from thence considered industry as a means of obtaining wealth and distinction, which encourag'd me, tho' I did not think that I should ever literally stand before kings, which, however, has since happened; for I have stood before five, and even had the honour of sitting down with one, the King of Denmark, to dinner.

> —*The Autobiography of Benjamin Franklin*

Today America's libraries provide an incredible range of services and information, from sophisticated science and medical research to historical documents, art and music, and collections of popular culture, as well as novels, magazines, toys, and games. Like Nick Grove's library in Meridian, Idaho, that houses a recording studio in an old bank vault (page 193), and Sam Leif working to help prisoners leave incarceration better than when they went in (page 111); and Sara Coney (page 193), whose job description changes from rock star to social worker to educator as she moves through the day serving different constituencies.

It's been my honor to stand before so many of these people who are fighting daily to bring access and information to the public. Some of them I met for only a few minutes, but in the past two years I've looked at their faces and read their words over and over and I feel like I know them. When I happen to see one of them, perhaps in a restaurant during an American Library Association convention, I can never shake the quickened pulse that comes with spotting a celebrity. And that is the right reaction; it's how we should all feel.

There's so much work being done in every community across the country by these people. This isn't a book about America's most significant libraries; it's a book about everyday libraries doing everyday work. They're just drops of rain in a thunderstorm, but together they work to make the ground fertile.

Wherever you are in America, there is a librarian fighting to get *you something*, whether it's a computer, an audio book, a children's book, a banned book, job skills, a citizenship test, a record deal, a movie to watch, a fishing rod, answers about thirteenth-century clothing, voter registration, local archives, a place to stay warm or cool or dry, a kayak on a breezy summer afternoon, or any of a thousand thousand other things. These librarians are fighting against incredible odds and against powerful forces and against ignorance and arrogance. They don't even know you, but they're getting up every morning, relentlessly building a colossus for you to stand on to see farther, reach higher, and achieve more. They're fighting for your right to access information.

How can you help libraries?

Acknowledgments

There are a lot of people who helped make this happen. First and foremost Naomi Gonzalez, who found me on Twitter and suggested that I photograph librarians. Without those few words, none of this would have happened. Jordan Teicher at *Slate* magazine enthusiastically took on this photo essay and put it in front of millions of people. My agent Gordon Warnock at Fuse Literary believed in this project from the very beginning and made things more effortless than I believed possible. Without any one of these three people, this would not be a thing that you are reading right now.

Thanks to *Slate*, Ingrid Conley-Abrams is now who you see when you Google "what a librarian looks like." She assisted me in many ways: tracking down librarians, scheduling people, telling stories, and being my guide through this universe. Likewise, Tina Coleman from the American Library Association helped tremendously in getting me access to librarians, inviting me to the conferences, and being an all-around cheerleader. John Chrastka from EveryLibrary, whose stirring words about the *Slate* essay gave me great legitimacy in the librarian community, is working hard every day to help struggling libraries—EveryLibrary can arrive like last-minute reinforcements to fill budget shortfalls and keep staff from being laid off. Andrew B. Wertheimer, PhD, made it his personal mission to help me succeed and tracked down the final librarian. Julie Cai acted as my assistant when she had better things to do. Carl handled my social media and made sure things got posted when people were awake. And of course thanks to my mother, who was the first librarian I knew.

Brian Siano shot video for the documentary and missed out on all the sights in every place we visited because he was busy editing it. Neil Gaiman was a tremendous supporter of this project and said "Absolutely!" without a moment's hesitation when I asked if he would narrate a documentary about librarians. Jeff Vandermeer

was the first Famous Author I approached about writing an essay, and he did so without hesitation. Things got easier when I was able to name-drop him afterward. Mike VanHelder wrangled the George R. R. Martin essay and I am grateful for that. Brad Hafford read much of this in draft and helped me find my way through the narrative.

When making a book you work for months or years on something and it's finally ripped from your chest like a beating heart while you scream that it's not ready yet. After that it's up to someone else to get your vision to a shelf, and that's a big leap. My editor, Becky Koh at Black Dog, made that leap easy. She stayed on top of the project, gently reminding me about deadlines and priorities and pushing extra goals to make this better than I would have been able to make it alone. Designer Kris Tobiassen did extraordinary work in making this look interesting.

My wife, Jennifer Summerfield (who was actually happy when I planned vacations around libraries), and her uncle, historian Tommy Davis, wrote the definitive history of Greybull, Wyoming (*Glimpses of Greybull's Past: A History of a Wyoming Railroad Town from 1887 to 1967*), while sitting in a back room of the Greybull Public Library, doing genuine scholarship in boxes of newspaper clippings, court records, and old phone books.

I'd also like to thank the people who didn't like this photo essay for whatever reason. I've learned over the years that there are three reasons something can go viral on the Internet: one is because everybody likes it, the second is because everybody dislikes it, and the third, and most effective, is because most people like it but some hate it with the blind, blazing passion of a collapsing star. If it weren't for the discussion about these photos, which raged on for a week, my essay would have been seen by far fewer people.

Thanks to transcribers Ingrid Conley-Abrams, John Pappas, Brian Heart, Cynthia Mari Orozco, and Loretta Mystischen, who turned hours and hours and pages of interviews into readable text.

I'm also grateful to the many Kickstarter backers who made it possible for me to do much of this work. Without them this either wouldn't have happened, or would have taken years:

Katherine Meusey

Mary Spila

Kendra

Pearl Ly

Jessamyn

Jennifer Talley

Manya Shorr

Joshua J. Smelser

Jenica Rogers

Rebekkah Smith Aldrich

Callie

Michelle Larson

Lea Ann Wade

Kyle Royer

Rob Lancefield

Daniel

Linda M. Dierks

Claudia Depkin

Allison Krumm

Jennifer French

Beth N

Conni Van Billiard

Brad

Shara McCaffrey

Keith Spears

Alisha Sams

Deborah Luchenbill

Joshua M. Cowles

Margaret Miner

Pete Vazquez

Soli Johnson

Becka Rahn

Gabriel Rosas

Clarissa

Anonymous

Ruth Genevieve

A. E. Charlton-Trujillo

J. Ashley Odell

Jim DelRosso

Meghan Cirrito

Laura Braunstein

Dr. Christina Will

Majorie

Janet Kowal

Crystal Bearden

Cynthia Mari Orozco

Virginia Coleman-Prisco

Kimberly Grad

Kerstin Eikel

Jared H

Sylvia Orner

James Szuch

Alvarado Annette

Mark Schlipper

Normandy Helmer

Amanda Brite

Miranda Latham-Jackson

Kendra Leigh Speeding

Rebecca van Kniest

Deb Zander

Ginny Southgate

Jenny Eritano

Mara

Leaghaire

Johanna Björk

Caroline Rockwood Schueren

R. J. Mansolino

Andrew Carl

Tiffany Marcheterre

Rahama

Amelia G

Janet Louise Brown

Tarek Charara

Whitney Johnson

Eileen

Regan Kugler

Laurel Eby

Robin

Sidra Vitale

Bob Wait

Dante

Meg

Elizabeth S. Bliss

Cathy Lin

sarah482

Index

Geographical Index